FOR THE LOVE OF BIRDS

The illustrations of Jane Shull Beasley

© 2021 Featherings

Published by Sandy Shull

ISBN: 978-1-59152-282-9

To find out more about Jane Shull Beasley and prints and greeting cards available, contact: www.featherings.com

sweetgrassbooks
an imprint of Farcountry Press

Produced by Sweetgrass Books
PO Box 5630, Helena, MT 59604
(800) 821-3874; www.sweetgrassbooks.com

For more information or to order extra copies of this book call Farcountry Press toll free at (800) 821-3874.

Designed by Bruce Capdeville
Real World Design, Helena, MT

Produced and designed in the United States of America.
Printed in Canada.

24 23 22 21 1 2 3 4

For the lovers of nature and birds — past, present, and future.

JANE SHULL BEASLEY
1930-2019

"Free as a bird"

Jane called herself a lover of nature and a nutty artist.

Jane began drawing at a young age which led to costume design and window decorating in college. She continued her drawing until she was introduced to clay in the early 1960s and quickly discovered her love of sculpture over the potter's wheel. She continued creating clay sculptures and reliefs for forty plus years.

As the years passed, she returned to drawing, using colored pencils as her medium. Her passion for birds and backyard birding led her to open Birds & Beasleys in 1993 in Helena, Montana, with her husband Ray.

Jane's love of birds and nature came from her father who taught her as a young girl to identify and respect birds and all of Mother Nature's creatures. She shared that belief with her children, grandchildren and great grandchildren, showing them how beautiful the world is through her eyes. Even in her late 80s, she'd marvel at a beautiful sunset and how she'd like to draw it.

Jane was a woman of many talents and adventures. She earned her pilot's license at 15 years of age. Jane was brave and didn't let anything or anyone get in her way. Once she made up her mind there was no going back.

Jane and Ray blended a family of seven children to create the Shull Beasley Bunch. She started Birds & Beasleys at the young age of 63. She hosted a weekly radio show on birding for 19 years. Jane had a distinctive voice, and she loved it when people would recognize her by her voice.

She remained an active birdwatcher into her eighties.

Jane was magical, charismatic, charming, gifted and kind. We all have something special to remember about Jane.

FOREWORD

My mom, Jane Shull Beasley, was a gifted and remarkable woman. She saw beauty in everything, especially nature.

Her dream was to create a book of Montana birds that included an illustration and a photo of each bird found in Montana. She wasn't able to finish "The Book," but here is a bevy of her bird, flower, and butterfly colored pencil drawings.

I hope you enjoy this collection and that it reminds you to pause, take time to explore and appreciate nature.

As Mom would say, "Have a Happy Bird Day!"

–Sandy

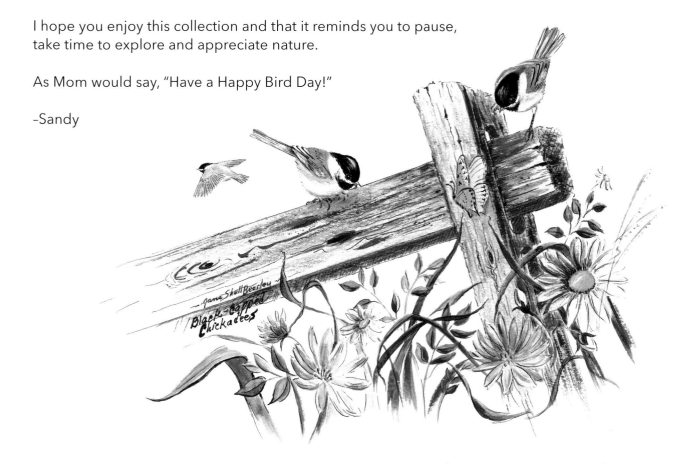

Black-capped Chickadee
Sexes alike

Size: 5"

Food: seeds, suet and insects

Birdfeeder bird: yes

Nest: cavity/birdhouse

Eggs: 5–7, white with fine brown markings

Jane says:

"everyone loves the chickadee"

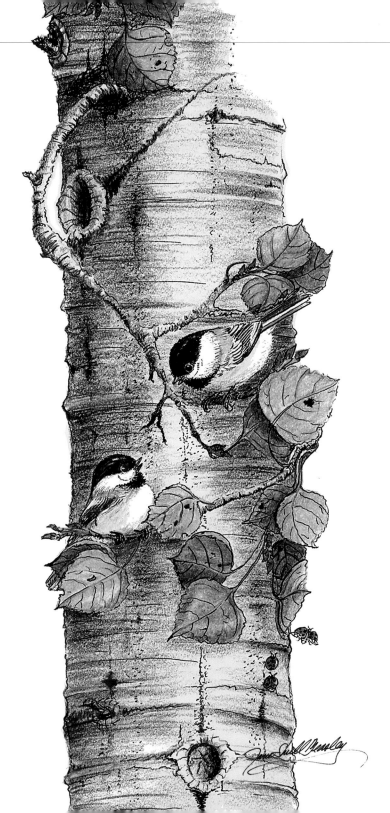

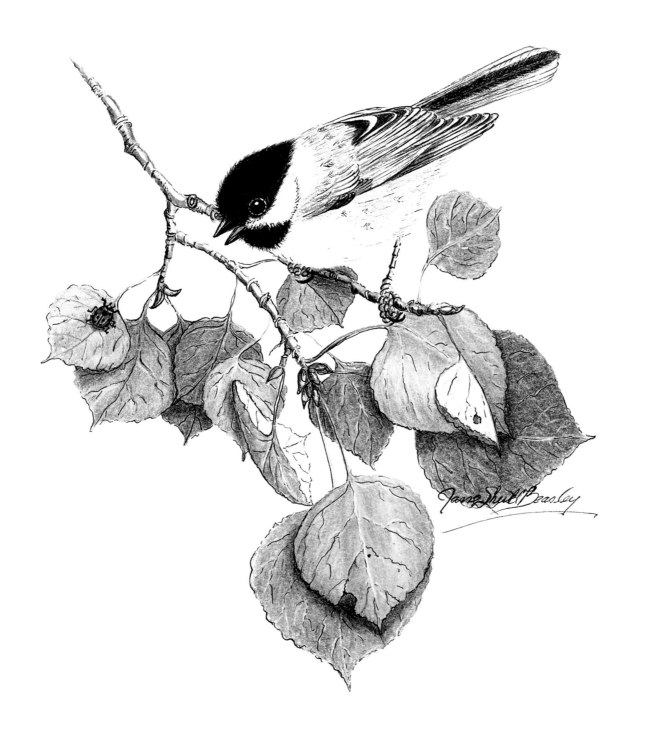

Jane says:

"if you are patient, they will feed from your hand"

Mountain Bluebird

Male

Size: 7"

Food: insects

Birdfeeder bird: no

Nest: cavity/birdhouse

Eggs: 4–6, pale blue without markings

Jane says:

"must have 1%₆" hole for the birdhouse because they are chubbier than the eastern or western bluebird"

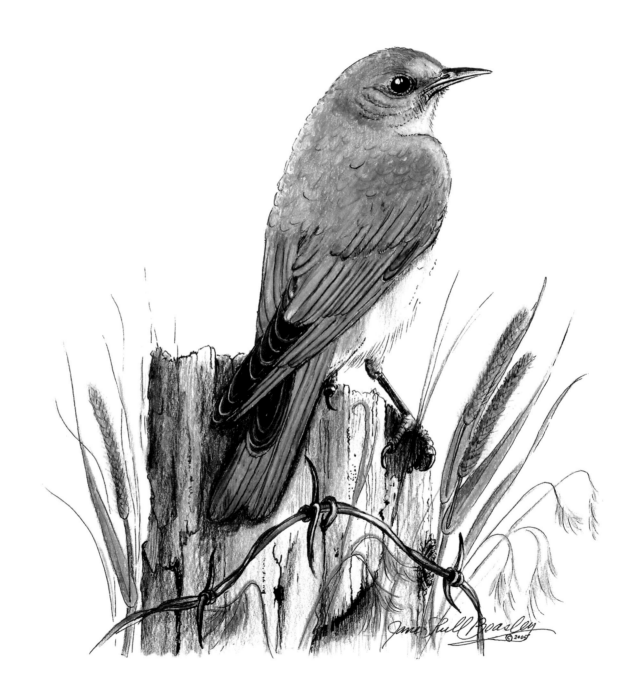

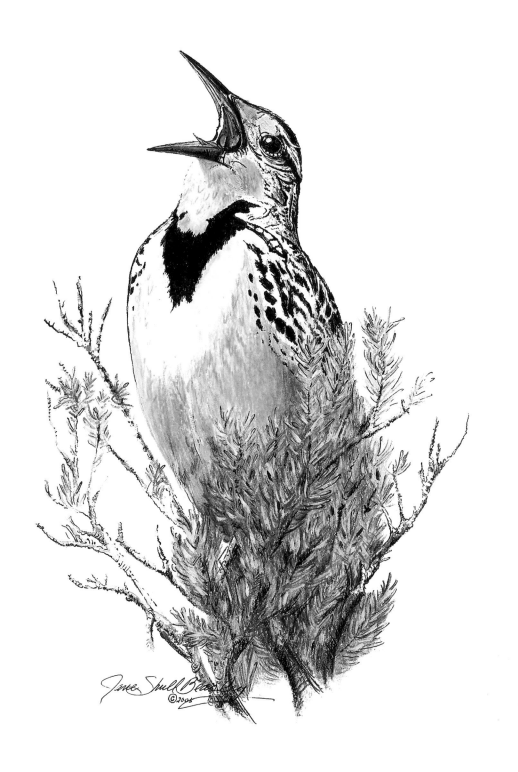

Western Meadowlark
Sexes alike

Size: 9"

Food: insects

Birdfeeder bird: no

Nest: cup on ground

Eggs: 3–5, white with brown markings

Jane says:

"when you hear the meadowlark you know winter is over and spring has arrived"

White-breasted Nuthatch

Sexes alike

Size: 5-6"

Food: seeds, suet and insects

Birdfeeder bird: yes

Nest: cavity/birdhouse

Eggs: 5-7, white with brown markings

Jane says:

"a nuthatch

moves down

the tree trunk

head first"

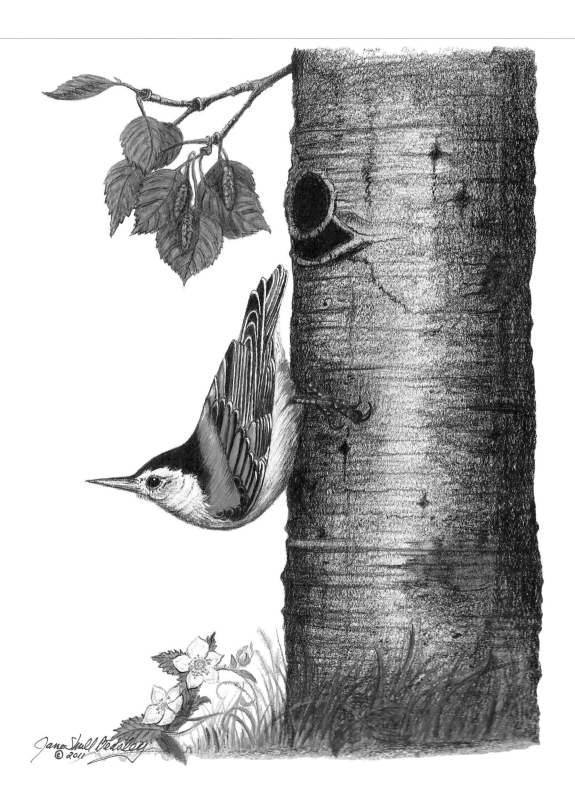

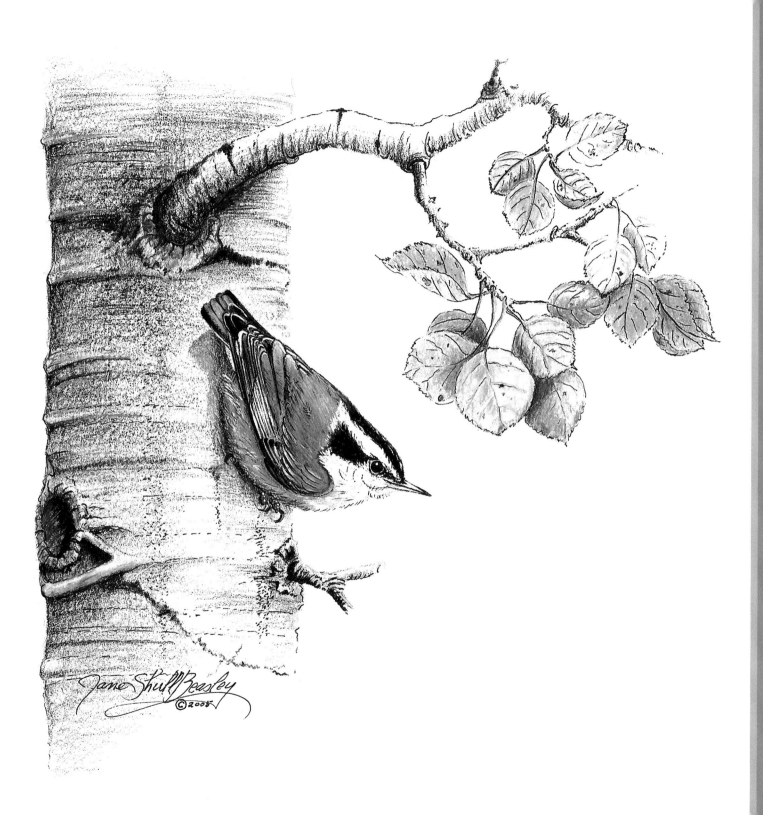

Red-breasted Nuthatch
Sexes alike

Size: 4.5"

Food: seeds, suet and insects

Birdfeeder bird: yes

Nest: cavity/birdhouse

Eggs: 5-6, white with red brown markings

Jane says:

"red-breasted nuthatchs aren't red; they are peanut butter color"

American Robin

Sexes alike

Size: 10"

Food: worms, insects and berries

Birdfeeder bird: no

Nest: cup

Eggs: 4–7, pale blue without markings

Jane says:

"isn't it amazing how the sight of a robin and hearing its cheerful song can bring a smile and brighten your day?"

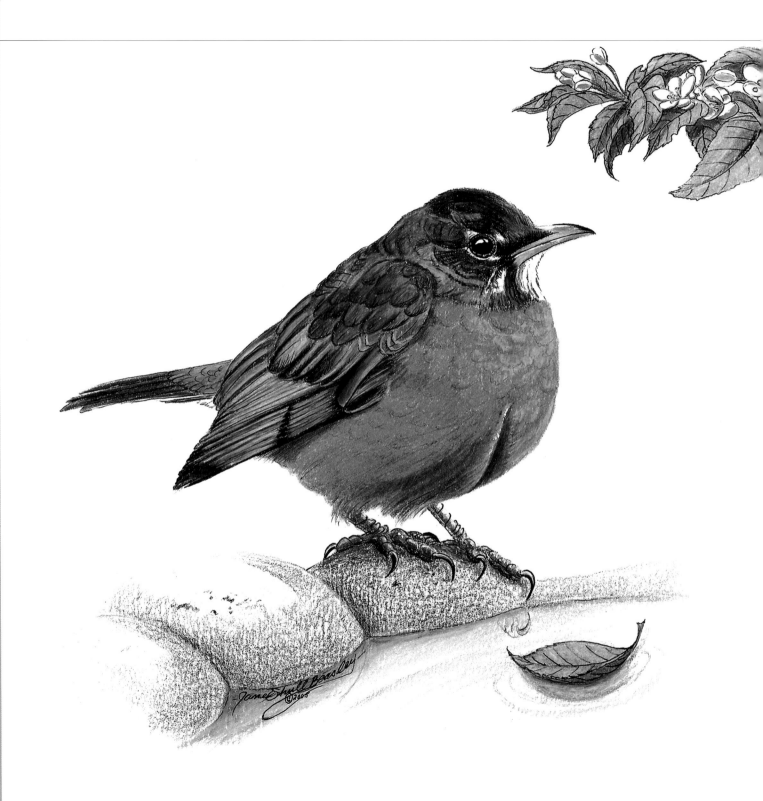

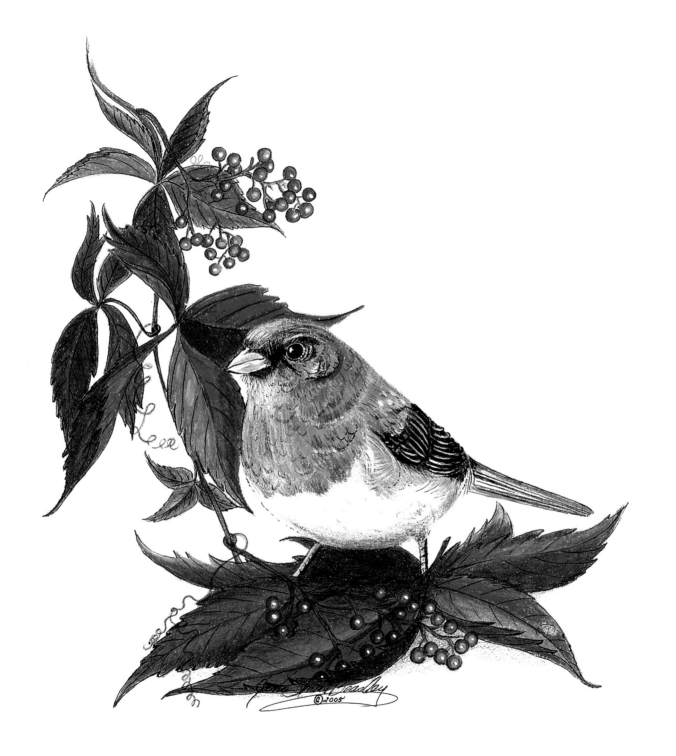

Dark-eyed Junco

Sexes alike

Size: 5.5"

Food: seeds and insects

Birdfeeder bird: yes, ground feeder

Nest: cup

Eggs: 3-5, white with reddish brown markings

Jane says:

"look for their

pink beak

and feet"

13

Great
Blue Heron

Sexes alike

Size: 42-52"

Food: small fish, frogs, snakes and insects

Birdfeeder bird: no

Nest: platform

Eggs: 3-5, blue-green without markings

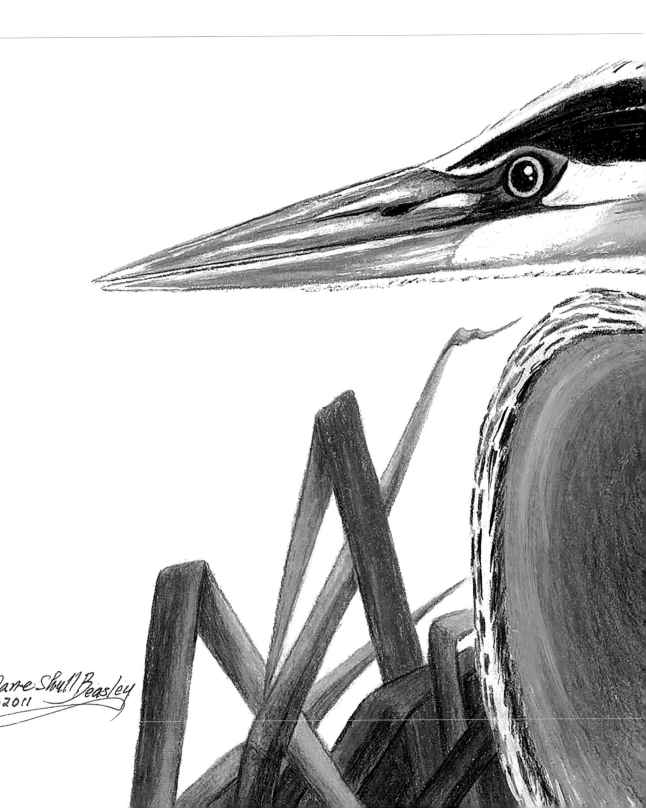

Jane says:

*"nests made
out of sticks in
treetops are
called rookeries"*

Western Tanager

Male

Size: 7"

Food: insects, fruit and suet

Birdfeeder bird: yes

Nest: cup

Eggs: 3-5, light blue with brown markings

Jane says:

"this brilliant yellow bird can often be seen eating on a suet feeder"

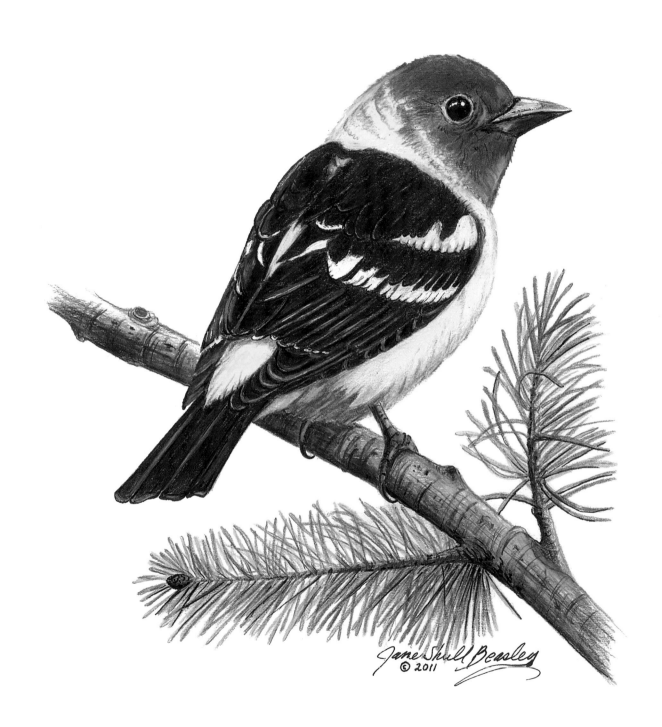

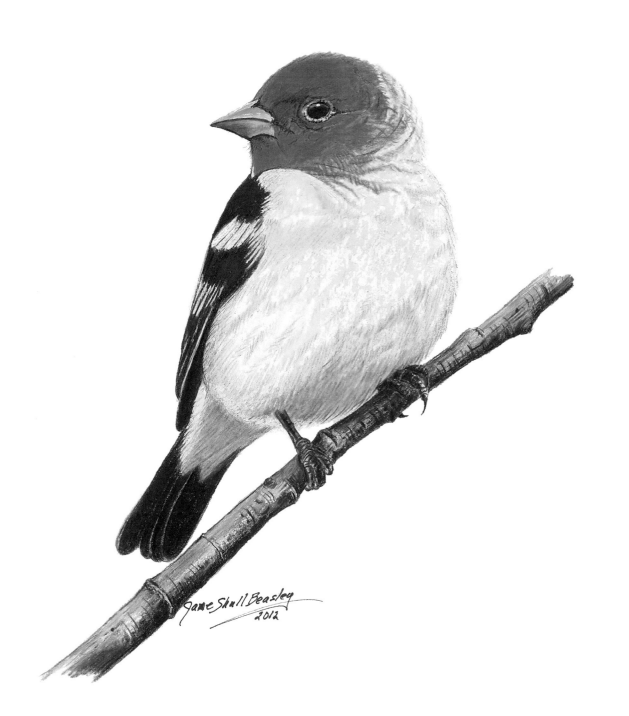

Jane says:

"has a stout triangular bill used to split and peel seeds"

Rufous Hummingbird

Male

Size: 3"

Food: nectar and insects

Birdfeeder bird: yes

Nest: cup

Eggs: 1-3, white without markings

Jane says:

"he is the cad of the bird world, multiple mates, doesn't help raise the young"

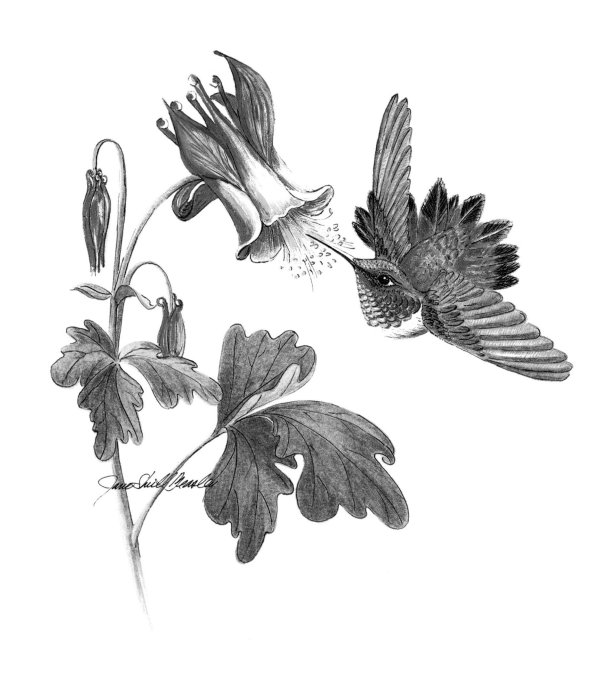

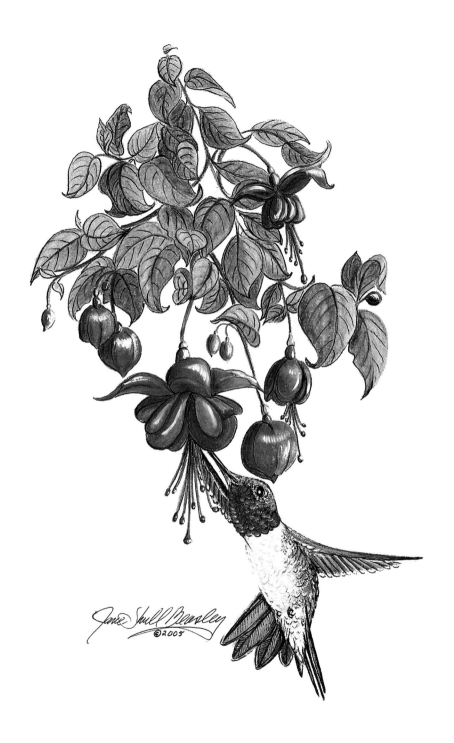

Ruby-throated Hummingbird
Male

Size: 3.5"

Food: nectar and insects

Birdfeeder bird: yes

Nest: cup

Eggs: 2, white
without markings

Jane says:

"most common
North American
hummingbird"

American Goldfinch
Male

Size: 5"

Food: seeds and insects

Birdfeeder bird: yes

Nest: cup

Eggs: 4-6, pale blue without markings

Jane says:

"also known as the wild canary"

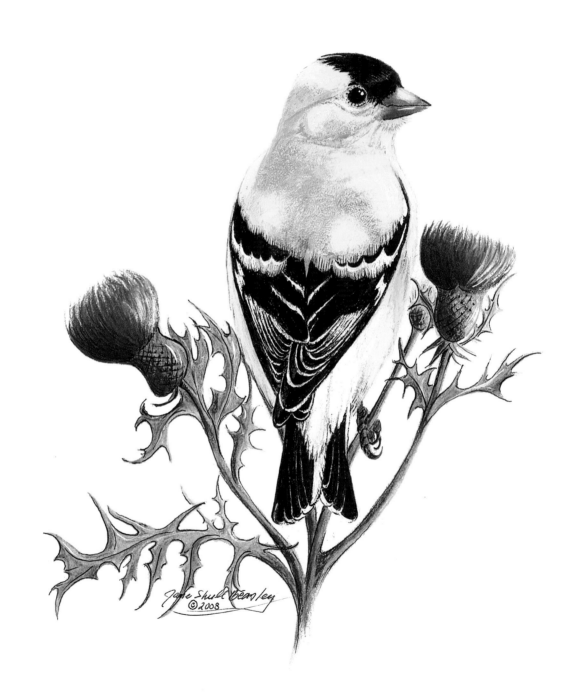

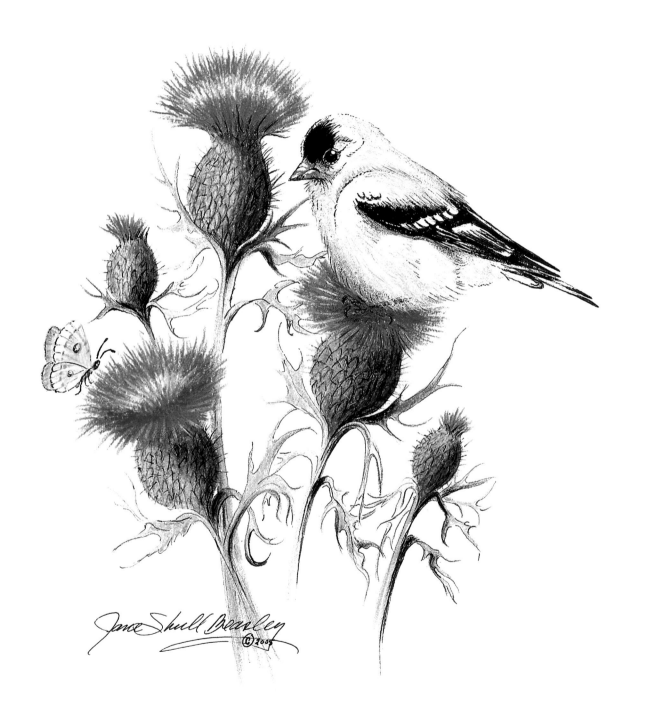

Jane says:

"nests in the summer when the thistle down is available to line their nests"

Lark
Bunting

Male

Size: 6.5"

Food: insects and seeds

Birdfeeder bird: no

Nest: cup

Eggs: 4-6, pale blue with markings

Jane says:

"Colorado's

state bird"

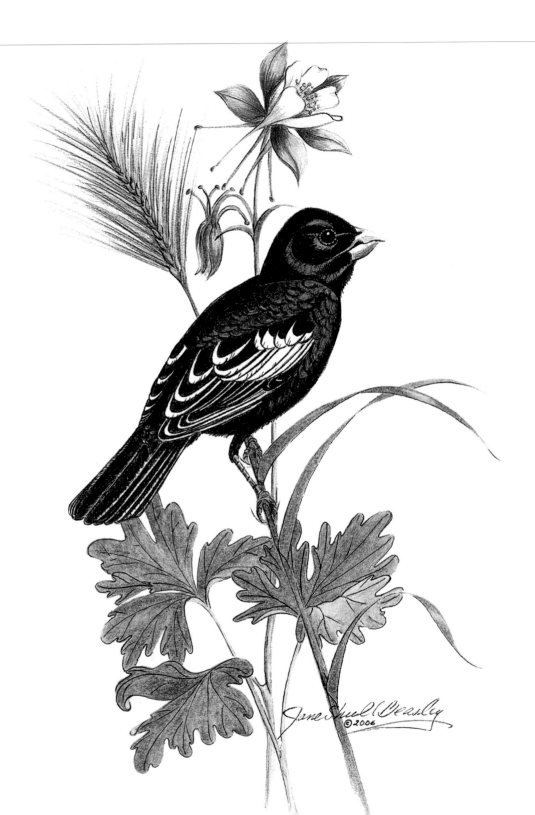

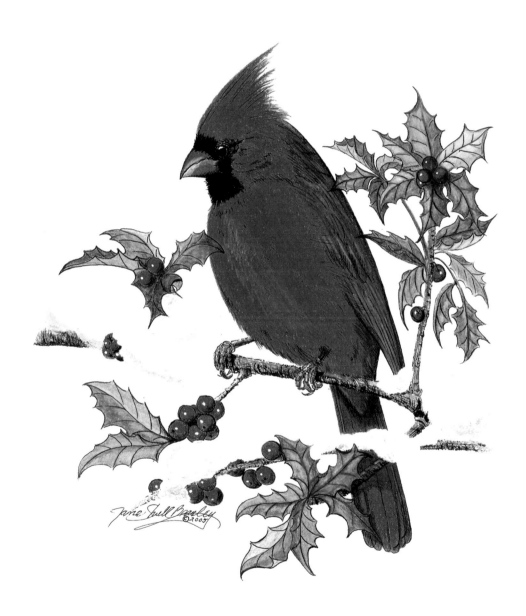

Northern Cardinal

Male

Size: 8–9"

Food: seeds, insects and fruit

Birdfeeder bird: yes

Nest: cup

Eggs: 3–4, buff white with brown markings

Jane says:

"they haven't made it to Montana yet"

Black-capped Chickadee
Sexes alike

Size: 5"

Food: seeds, suet and insects

Birdfeeder bird: yes

Nest: cavity/birdhouse

Eggs: 5-7, white with fine brown markings

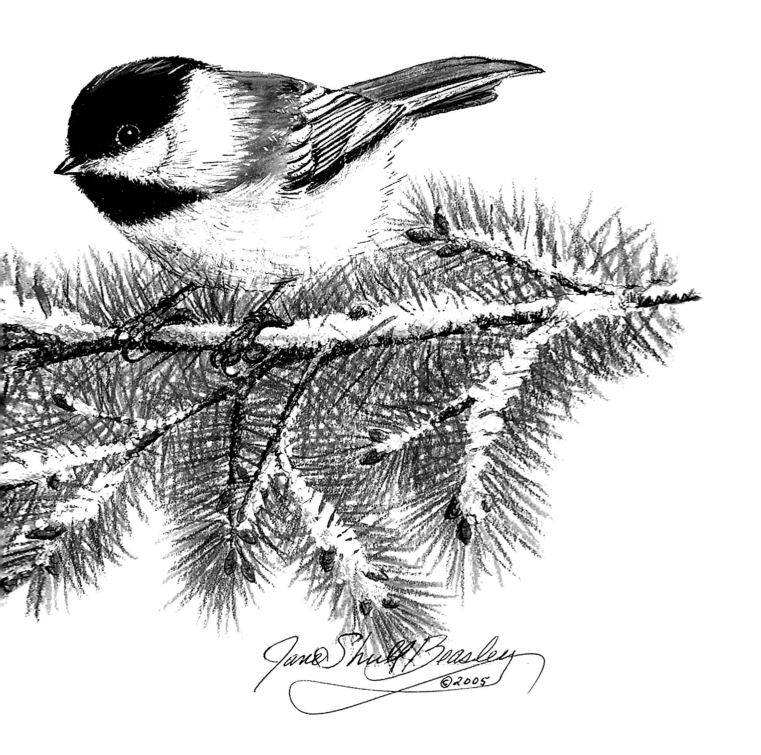

Jane says:

"kids know the chickadee as the 'cheese-bur-ger' bird"

Red-winged Blackbird

Male

Size: 8.5"

Food: insects and seed

Birdfeeder bird: yes

Nest: cup

Eggs: 3-4, bluish green with brown markings

Jane says:

"the call of the blackbird is the sign that spring has arrived"

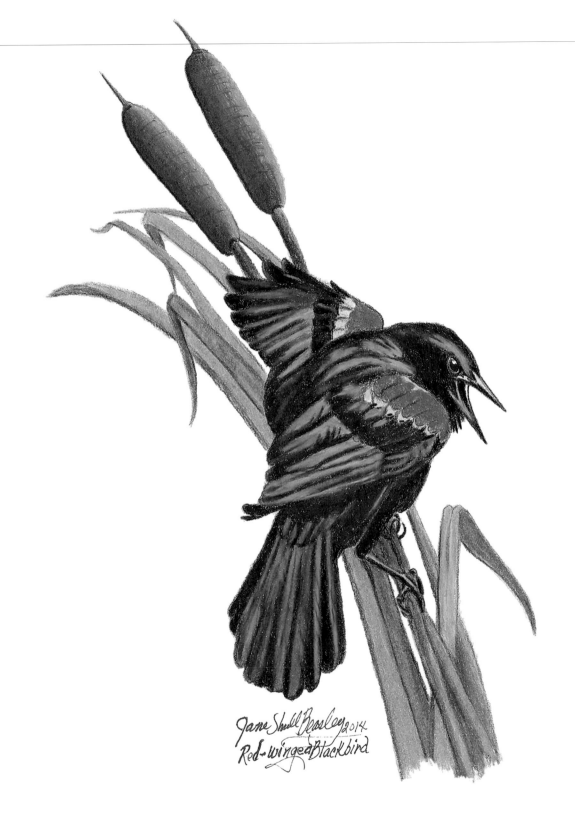

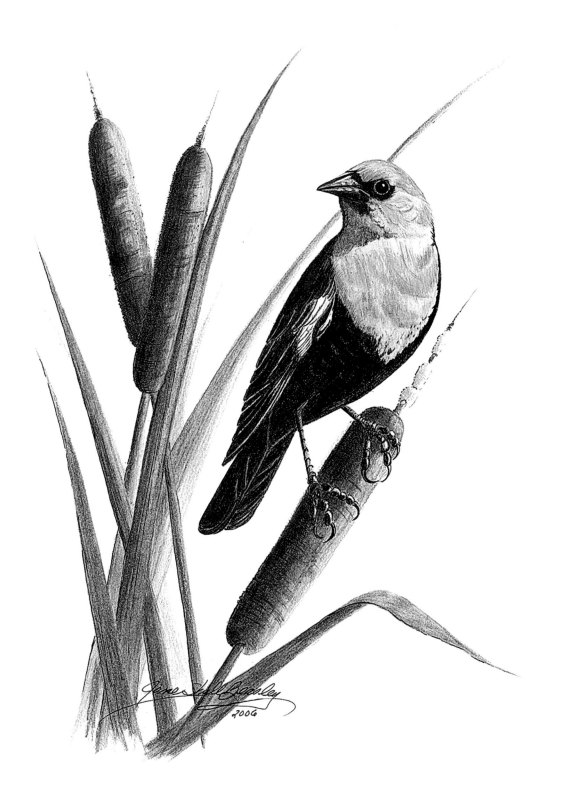

Yellow-headed Blackbird

Male

Size: 9–11"

Food: insects and seeds

Birdfeeder bird: sometimes

Nest: cup

Eggs: 3-5, greenish white with brown markings

Jane says:

"a black bird with a brilliant yellow head, finally a bird named correctly"

Golden Eagle

Sexes alike

Size: 30-40"

Food: mammals, birds, reptiles and insects

Birdfeeder bird: no

Nest: platform

Eggs: 2, white with brown markings

Jane says:

"do not breed until they are at least five years old"

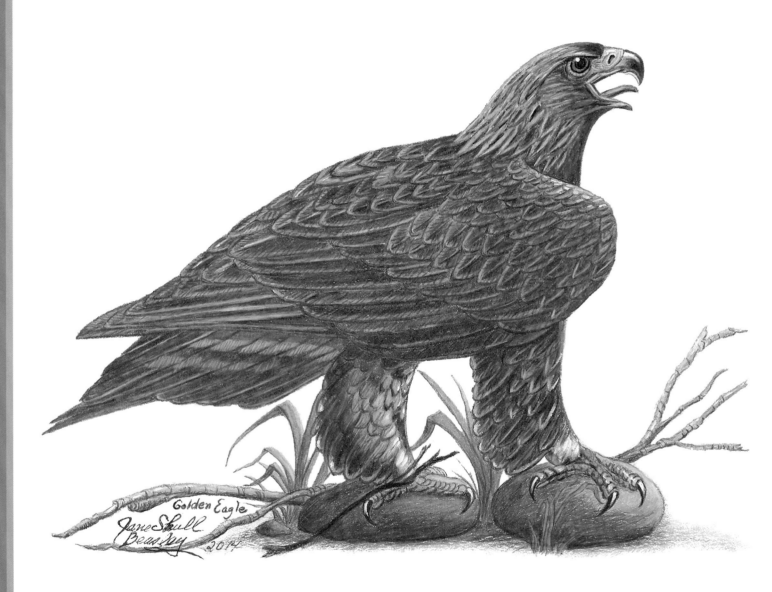

Golden Eagle
Jane Shull
Beasley
2014

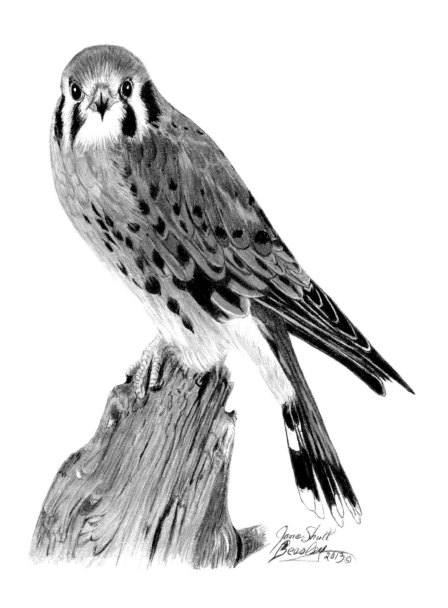

American Kestrel

Sexes alike

Size: 11"

Food: birds, insects and small mammals

Birdfeeder bird: no

Nest: cavity

Eggs: 4-5, white with brown markings

Jane says:

"this is the small falcon you see along the highway on the power lines; also known as the sparrow hawk"

House Finch

Male (left) and female

Size: 5"

Food: seed and fruit

Birdfeeder bird: yes

Nest: cup

Eggs: 4–5, pale blue lightly marked

Jane says:

"will often nest in wreaths hung on the porch"

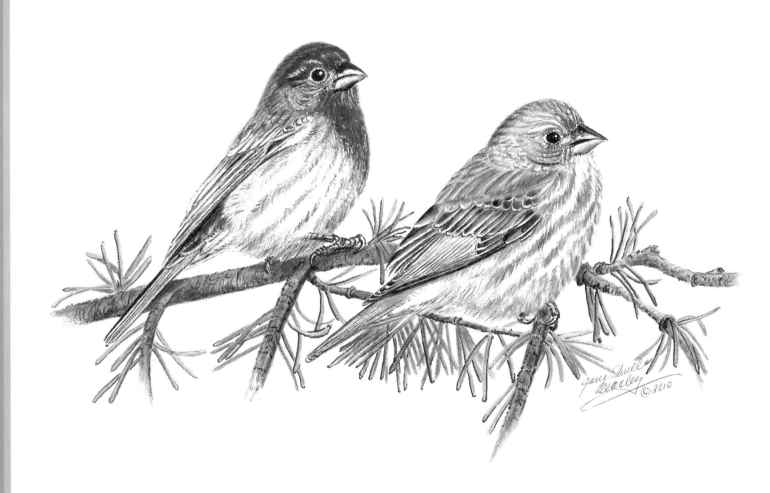

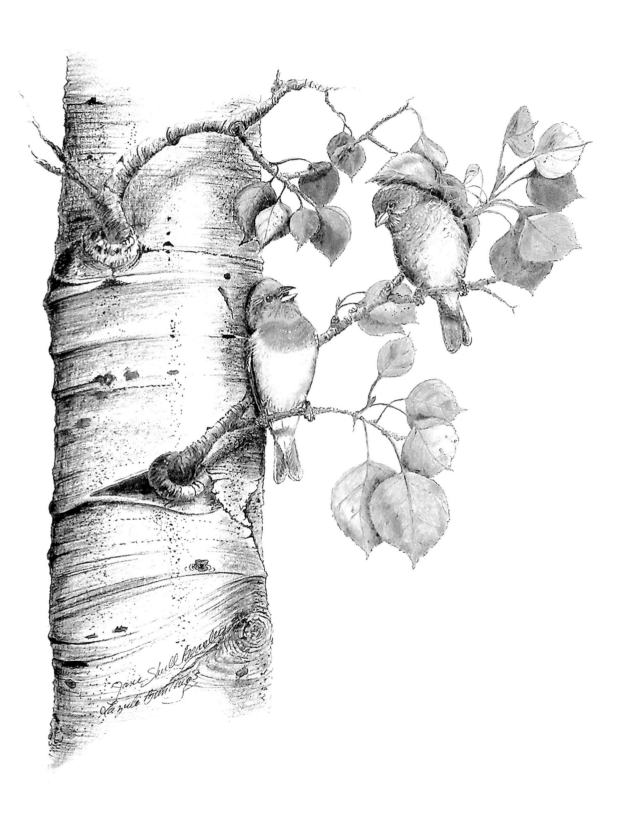

Lazuli Bunting

Male (left) and female

Size: 5.5"

Food: insects and seeds

Birdfeeder bird: yes

Nest: cup

Eggs: 3–5, pale blue
without markings

Jane says:

*"a summer
tourist that likes
to eat millet
on the ground"*

White-tailed Ptarmigan

Male

Size: 12"

Food: plants and insects

Birdfeeder bird: no

Nest: ground

Eggs: 4–16 buff with darker marks

Jane says:

"changes from brown plumage to white feathers in the winter"

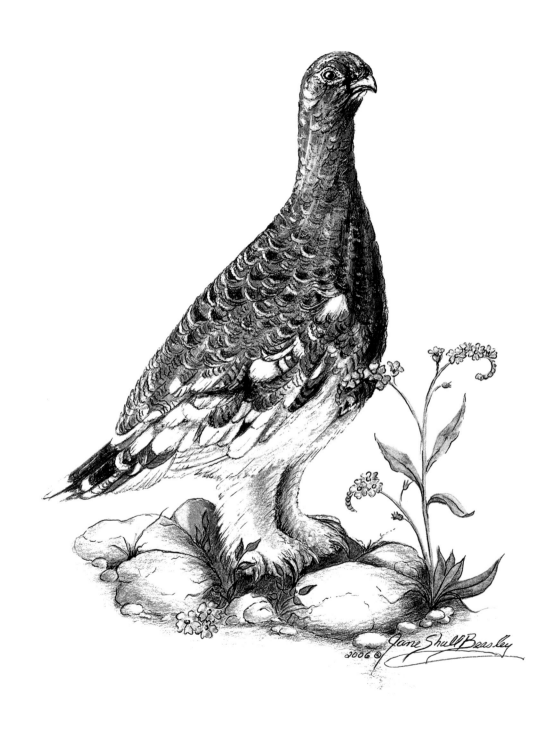

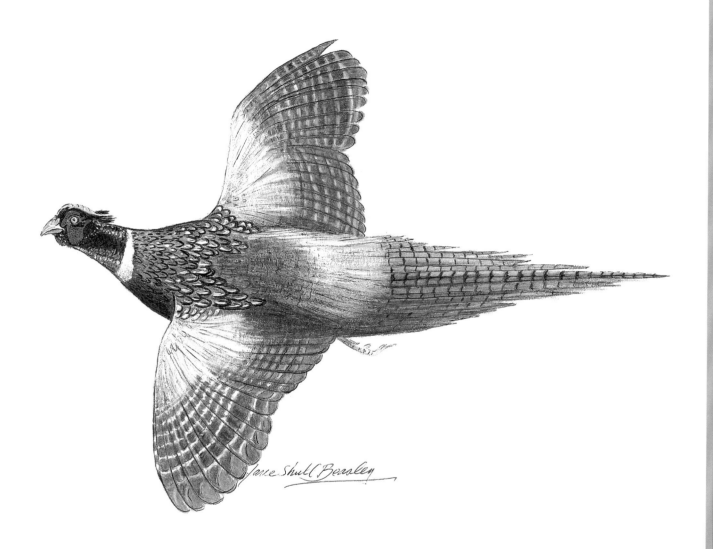

Ring-necked Pheasant
Male

Size: 30-36"

Food: seeds and insects

Birdfeeder bird: no

Nest: ground

Eggs: 8-10, olive brown without markings

Jane says:

"whose spectacular colored feathers make great fly-fishing flies"

Evening Grosbeak

Male

Size: 8"

Food: seeds, insects and fruit

Birdfeeder bird: yes

Nest: cup

Eggs: 3-4, blue with brown markings

Jane says:

"irruptive species—here today and gone tomorrow"

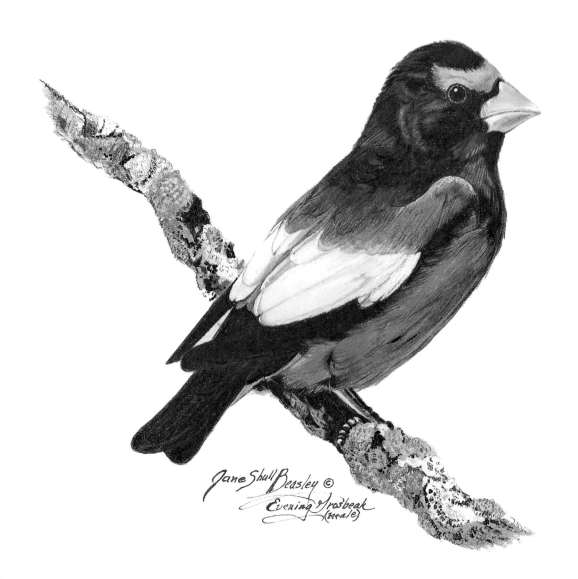

Jane Shull Beasley ©
Evening Grosbeak
(male)

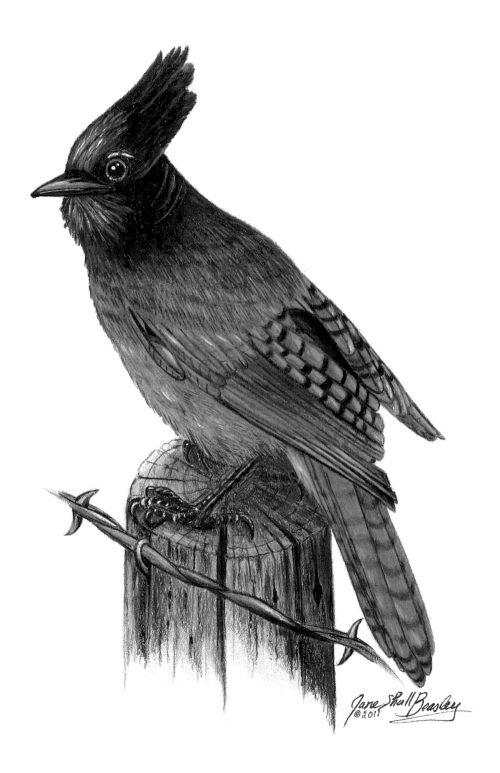

Steller's Jay

Sexes alike

Size: 11"

Food: seeds and insects

Birdfeeder bird: yes

Nest: cup

Eggs: 3-5, pale green with brown markings

Jane says:

"will often come to your feeder for millet or peanuts"

Cactus Wren

Sexes alike

Size: 8"

Food: insects, fruit and seeds

Birdfeeder bird: yes

Nest: cup

Eggs: 3-4, pale white to pink with brown markings

Jane says:

"the largest wren in North America"

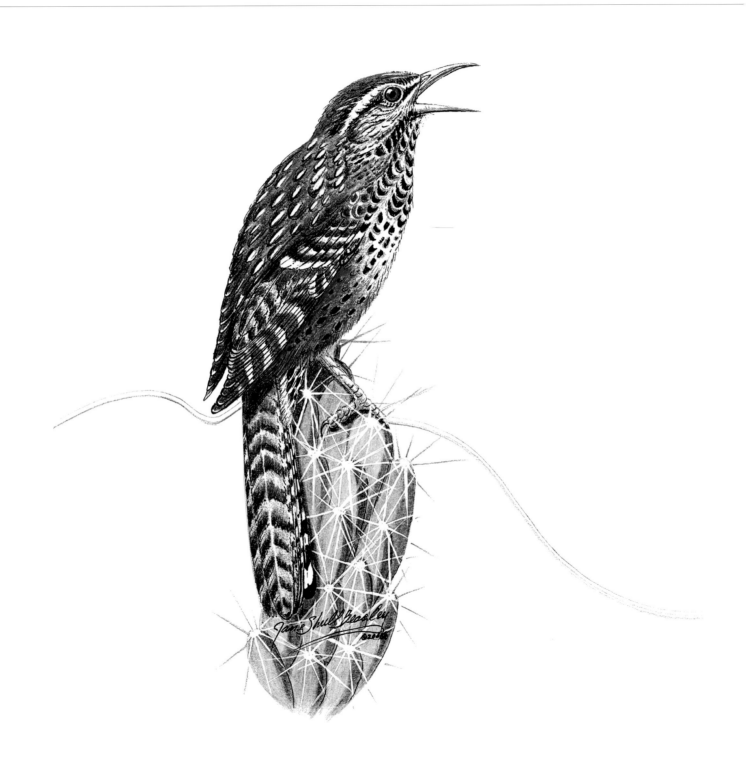

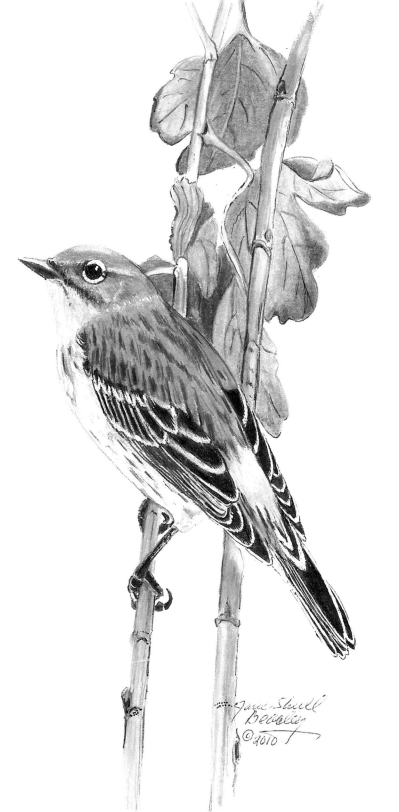

Yellow-rumped Warbler

Female

Size: 5-6"

Food: insects and berries

Birdfeeder bird: no

Nest: cup

Eggs: 4-5, white with brown markings

Jane says:

"the most versatile foragers of all warblers"

Cedar (top) and Bohemian Waxwing

Sexes alike

Size: 8"

Food: insects and fruit

Birdfeeder bird: no

Nest: cup

Eggs: 2-6, pale blue gray with black spots

Jane says:

"the crest and the black mask tell you it is a waxwing and the rust colored feathers under the tail tell you it is a Bohemian"

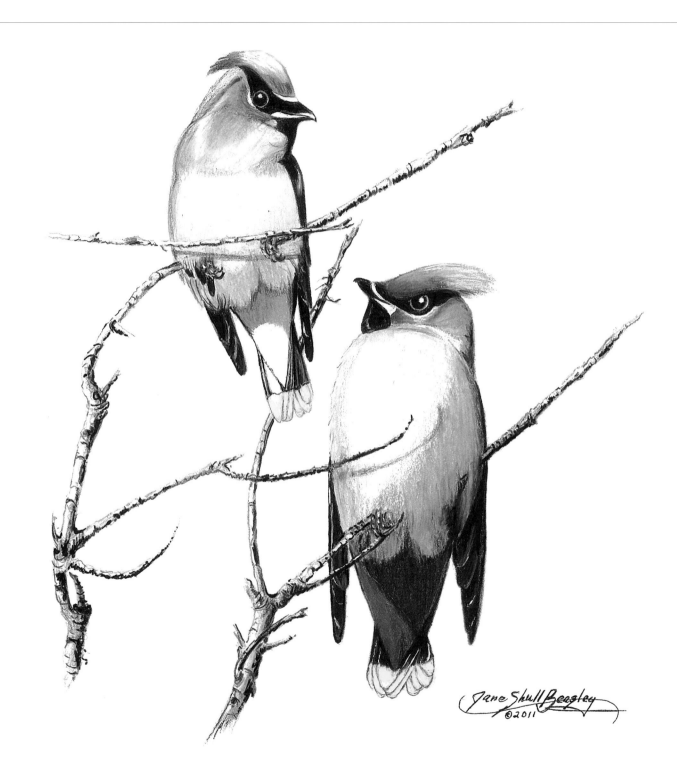

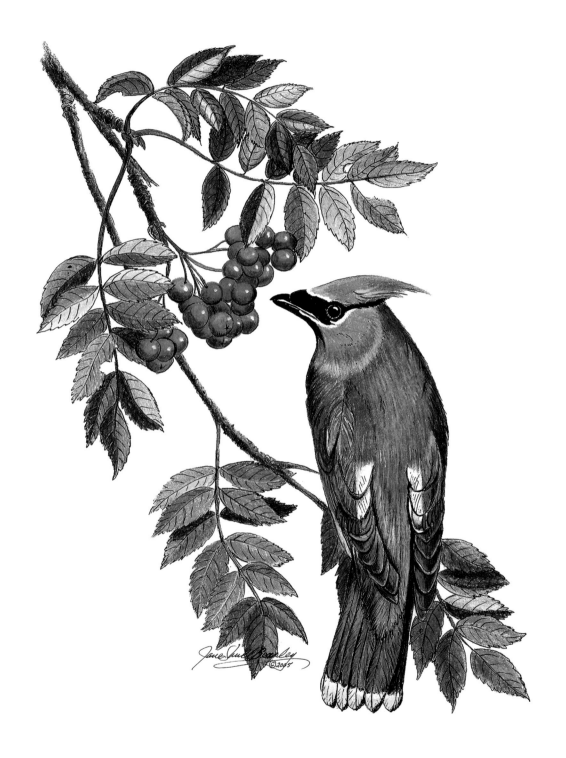

Cedar Waxwing

Sexes alike

Size: 7.5"

Food: cedar cones and berries

Birdfeeder bird: no

Nest: cup

Eggs: 4–6, pale blue with brown markings

Jane says:

"the best way to identify a Cedar Waxwing is by the white feathers under its tail"

Greater Roadrunner

Sexes alike

Size: 23"

Food: insects and mammals

Birdfeeder bird: no

Nest: platform

Eggs: 4-6, yellowish white

Jane says:

"males do most of the incubating and feeding of the young. 'beep beep'"

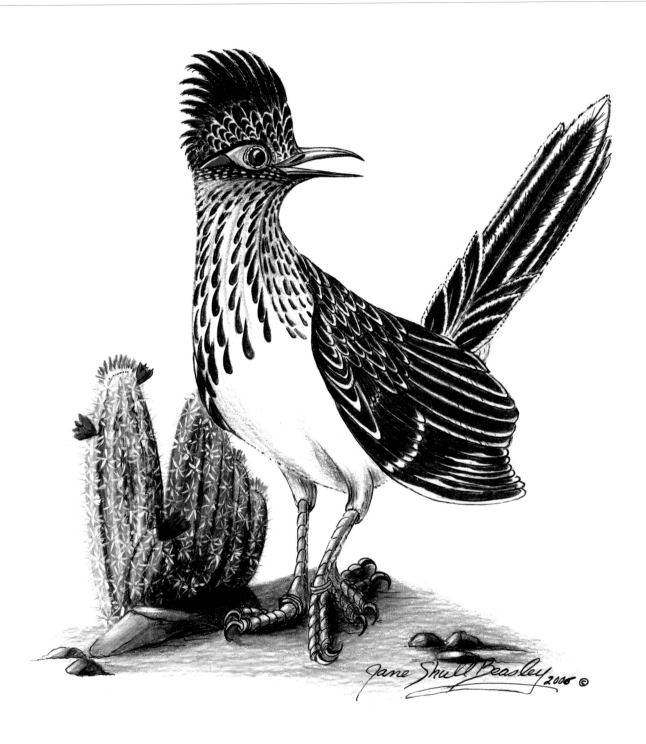

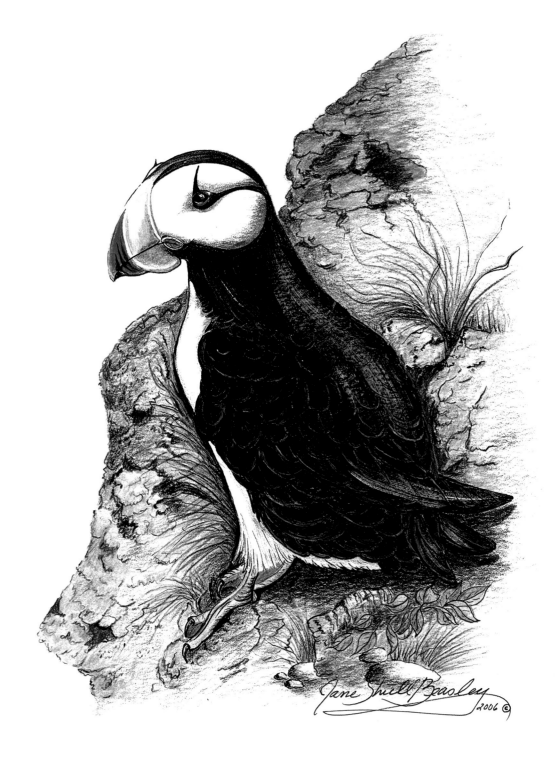

Horned Puffin

Sexes alike

Size: 15"

Food: fish

Birdfeeder bird: no

Nest: cliff

Eggs: 1, whitish with dark marks

Jane says:

"clown-like face with orange feet"

Rufous Hummingbird

Male

Size: 3"

Food: nectar and insects

Birdfeeder bird: yes

Nest: cup

Eggs: 1–3, white without markings

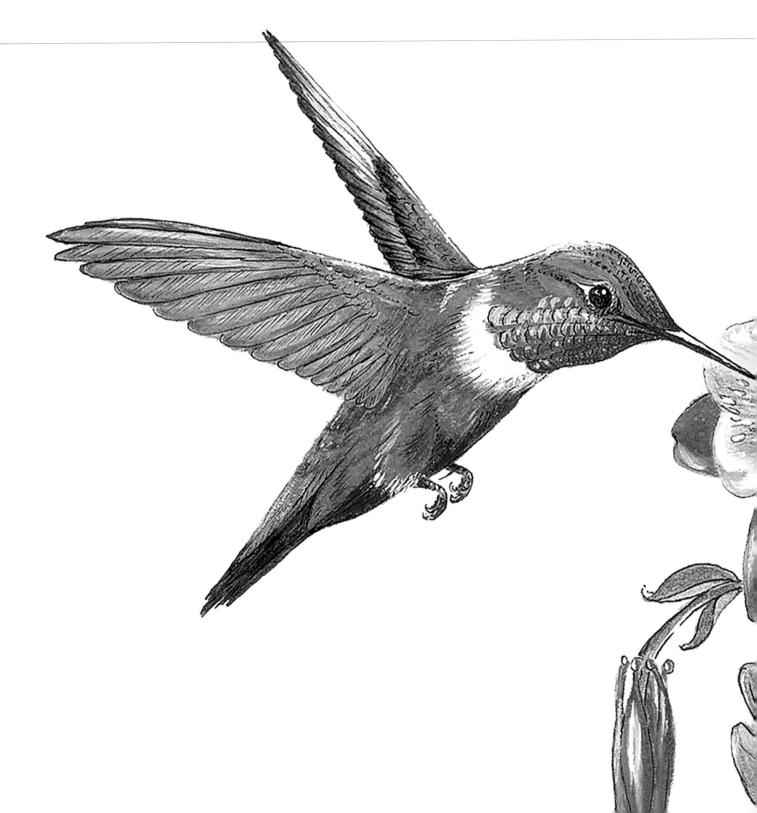

Jane says:

*"the feistiest
hummingbird in
North America"*

43

Bald
Eagle

Sexes alike

Size: 31–37"

Food: fish, ducks
and carrion

Birdfeeder bird: no

Nest: platform

Eggs: 2, off-white
without markings

Jane says:

"builds huge

nests, which can

be 12 feet across

and weigh

1,000 pounds"

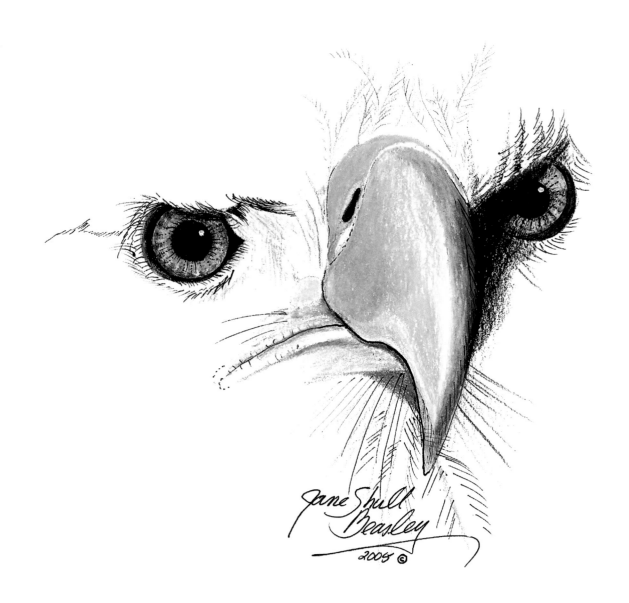

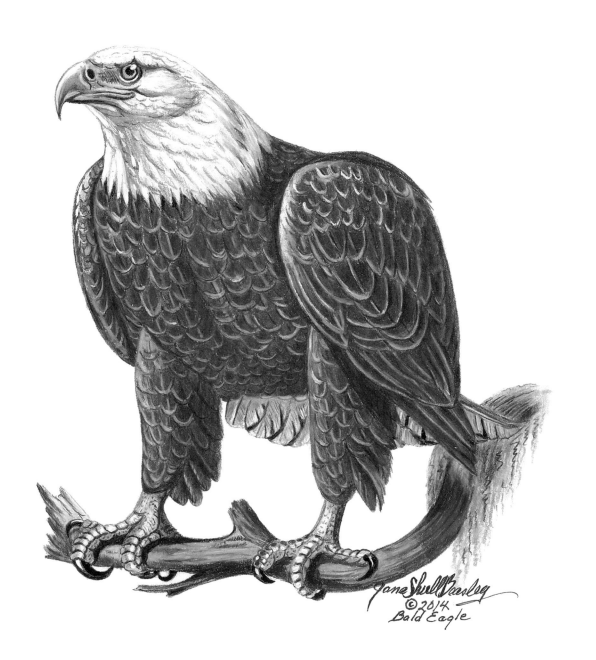

Jane says:

*"are monogamous
and pairs mate
for life"*

Mountain Chickadee

Sexes alike

Size: 5.5"

Food: seeds, suet and insects

Birdfeeder bird: yes

Nest: cavity/birdhouse

Eggs: 5-8, white without markings

Jane says:

"scruffier than the black-capped and has a white eyebrow"

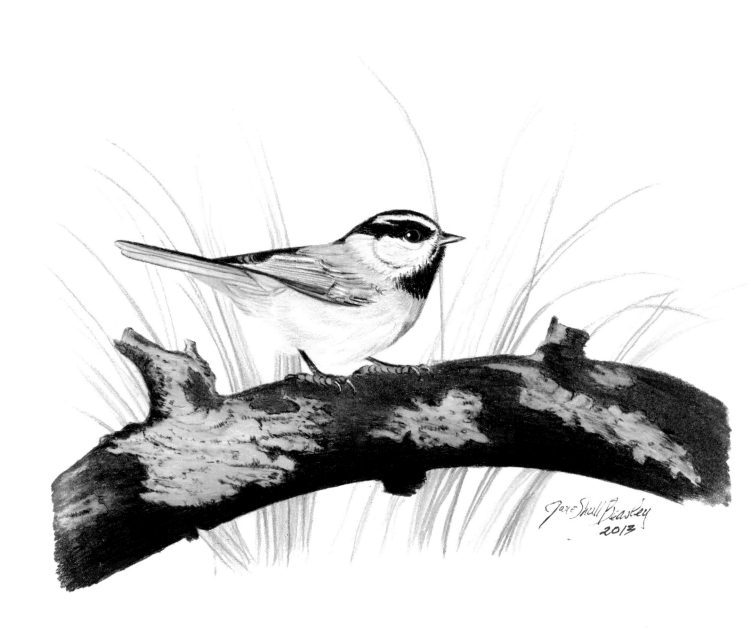

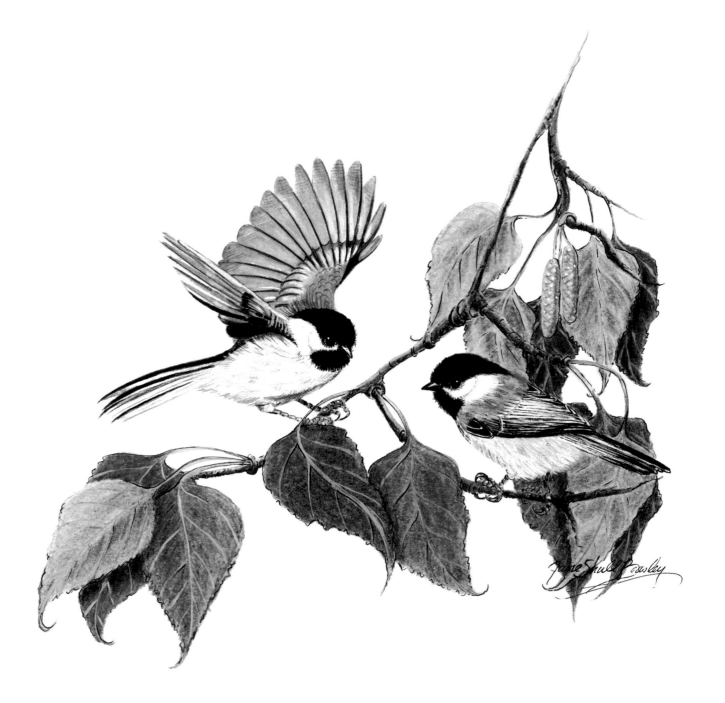

Black–capped Chickadee
Sexes alike

Size: 5"

Food: seeds, suet and insects

Birdfeeder bird: yes

Nest: cavity/birdhouse

Eggs: 5-7, white with fine brown markings

Jane says:

"call is the chick-a-dee-dee-dee, which gives this bird its name'"

Black-billed Magpie

Sexes alike

Size: 20"

Food: carrion, insects, seeds and suet

Birdfeeder bird: yes

Nest: sticks in a tree

Eggs: 5-8, green with brown markings

Jane says:

"this bird is smart as a whip and a rascal"

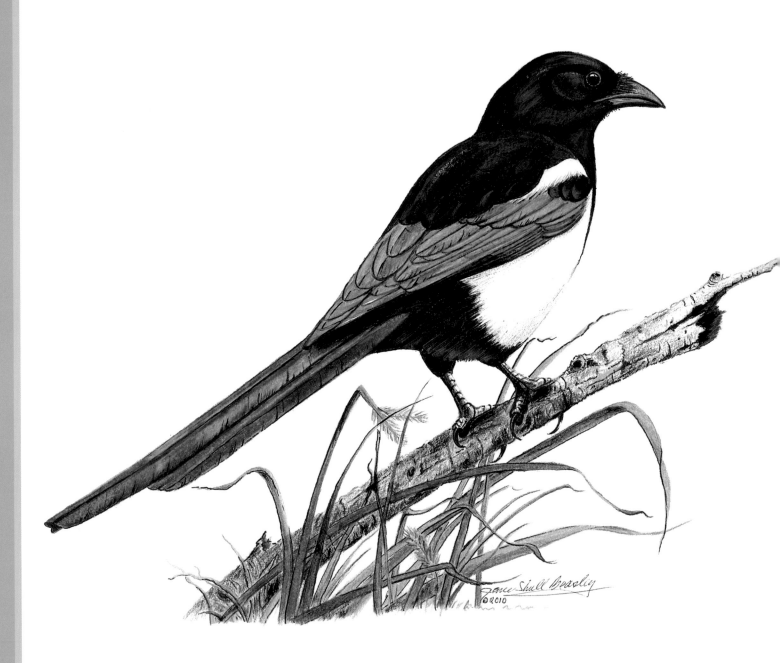

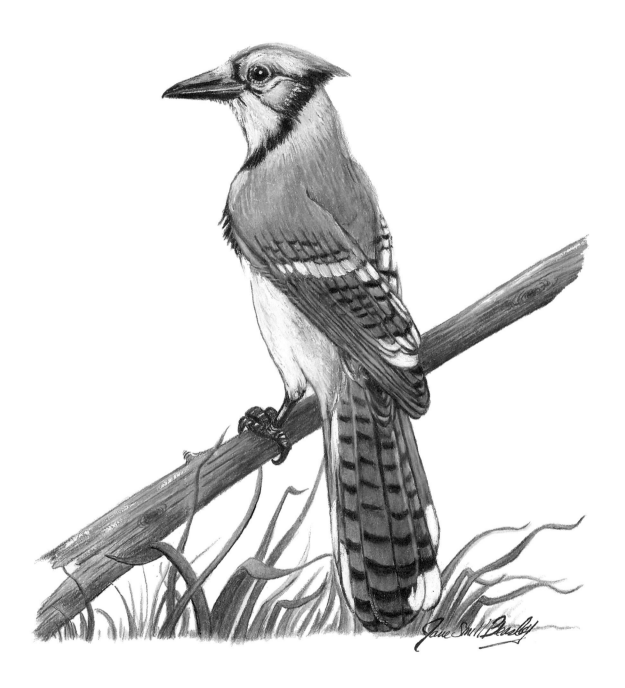

Blue Jay
Sexes alike

Size: 12"

Food: seeds, insects and fruit

Birdfeeder bird: yes

Nest: cup

Eggs: 4–5 greenish blue with brown markings

Jane says:

"this is the magpie of the midwest and east"

Common Raven

Sexes alike

Size: 25"

Food: insects, fruit and small mammals

Birdfeeder bird: no

Nest: platform

Eggs: 4–6, pale green with brown markings

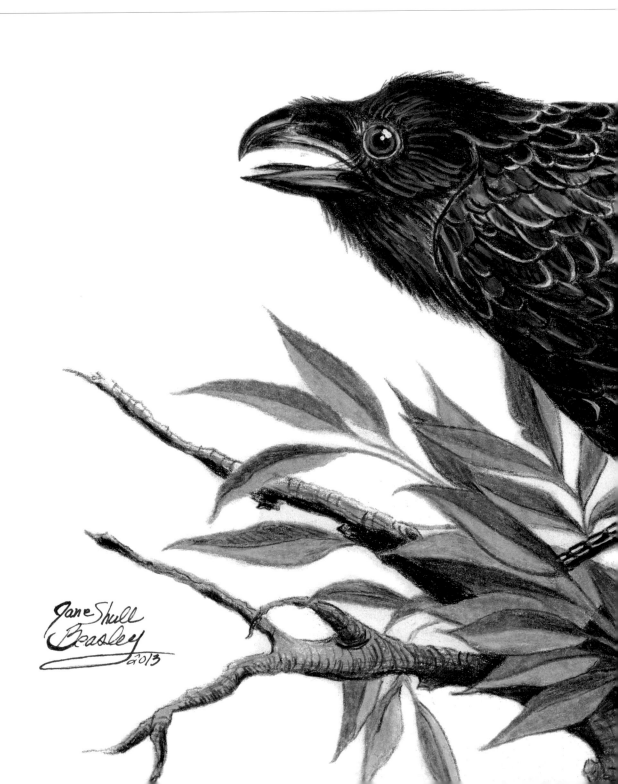

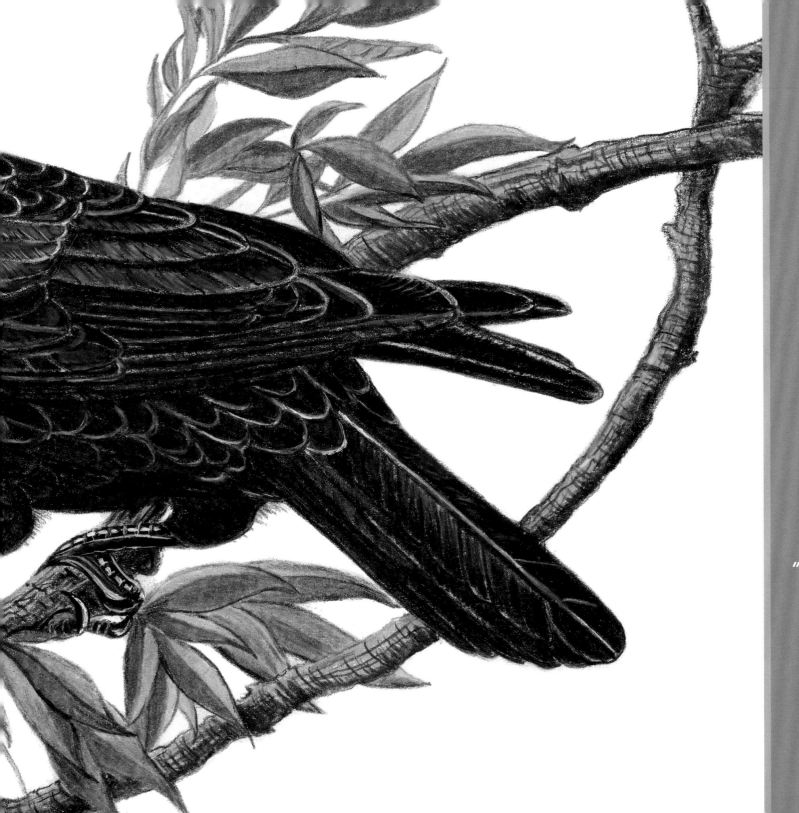

Jane says:

"larger and louder than the crow with a wedge shaped tail; one of the smartest birds"

Northern Saw-whet Owl

Sexes alike

Size: 8"

Food: small mammals and insects

Birdfeeder bird: no

Nest: cavity

Eggs: 4-7, white

Jane says:

"its call sounds like a saw being sharpened on a whetstone"

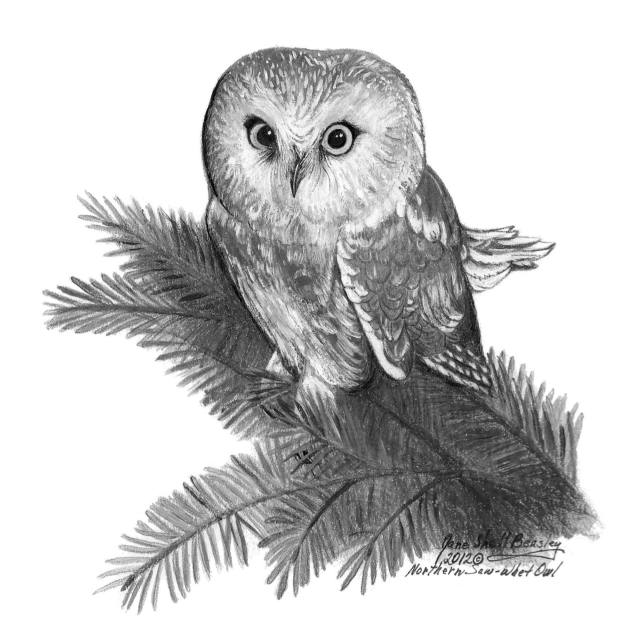

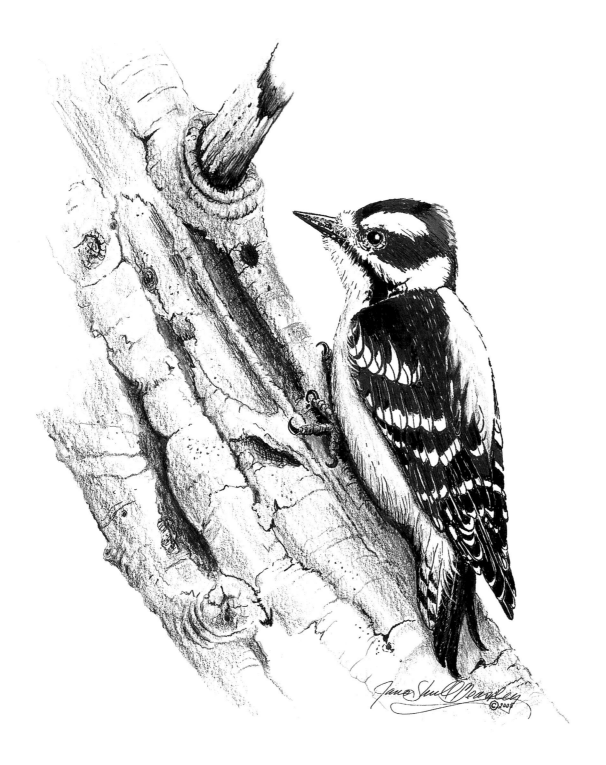

Downy Woodpecker

Male

Size: 6.5"

Food: seeds, insects and suet

Birdfeeder bird: yes

Nest: cavity/birdhouse

Eggs: 3-5, white without markings

Jane says:

"smaller than the Hairy Woodpecker; its beak is about half the length of its head"

53

Pine Siskin

Sexes alike

Size: 5"

Food: seeds

Birdfeeder bird: yes

Nest: cup

Eggs: 3-4, greenish blue with brown markings

Jane says:

"small striped bird with splashes of yellow, a forked tail and needle-like beak"

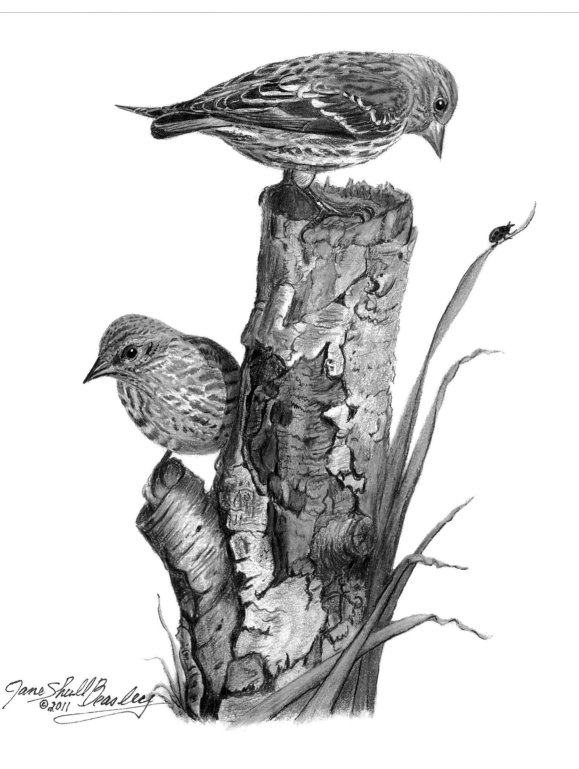

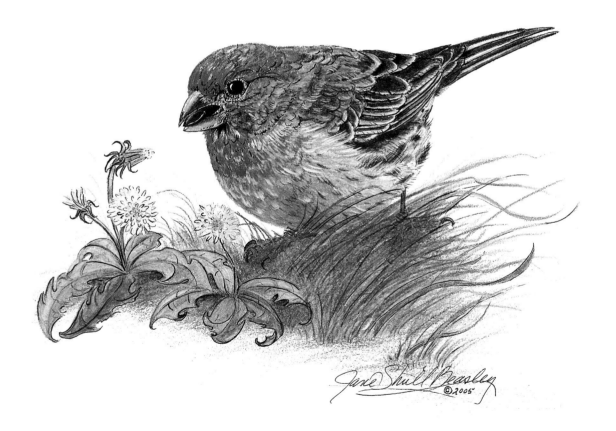

House Finch
Male

Size: 5"

Food: seed and fruit

Birdfeeder bird: yes

Nest: cup

Eggs: 4–5, pale blue lightly marked

Jane says:

"the male has a beautiful throaty song in the spring when attracting a mate"

Belted Kingfisher

Sexes alike

Size: 13"

Food: small fish

Birdfeeder bird: no

Nest: cavity

Eggs: 6–7, white, no markings

Jane says:

"they chatter as they fly up and down the stream"

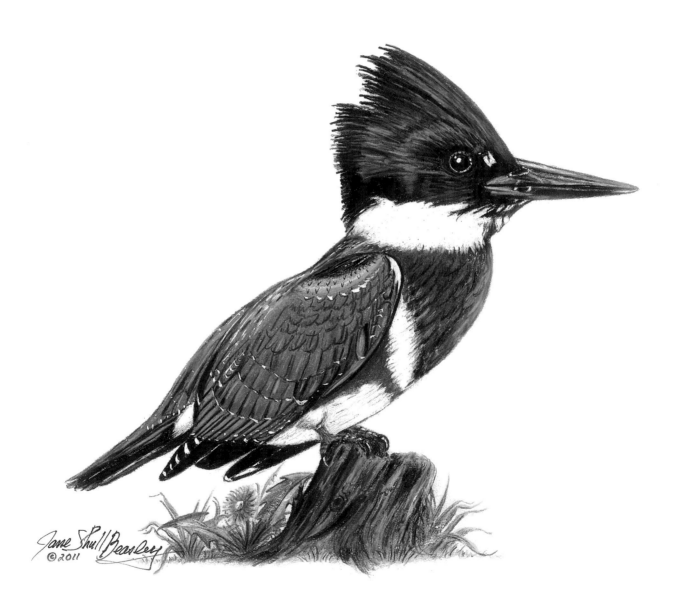

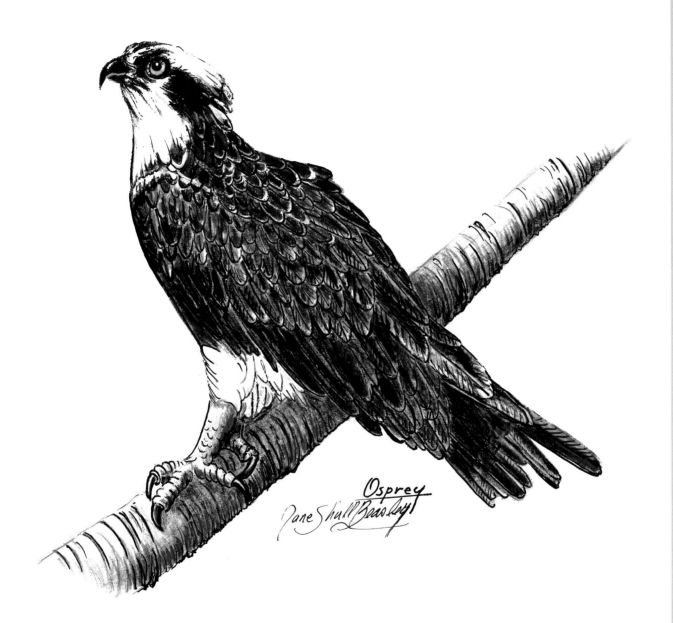

Osprey
Sexes alike

Size: 24"

Food: fish

Birdfeeder bird: no

Nest: platform

Eggs: 2–4, white with brownish markings

Jane says:

"often seen along rivers and will nest on telephone poles"

Clark's Nutcracker

Sexes alike

Size: 12"

Food: seeds, insects and berries

Birdfeeder bird: yes

Nest: cup

Eggs: 2–5, pale green with brown markings

Jane says:

"the nutcracker stashes over 1,000 caches of seed and can find them later in the winter"

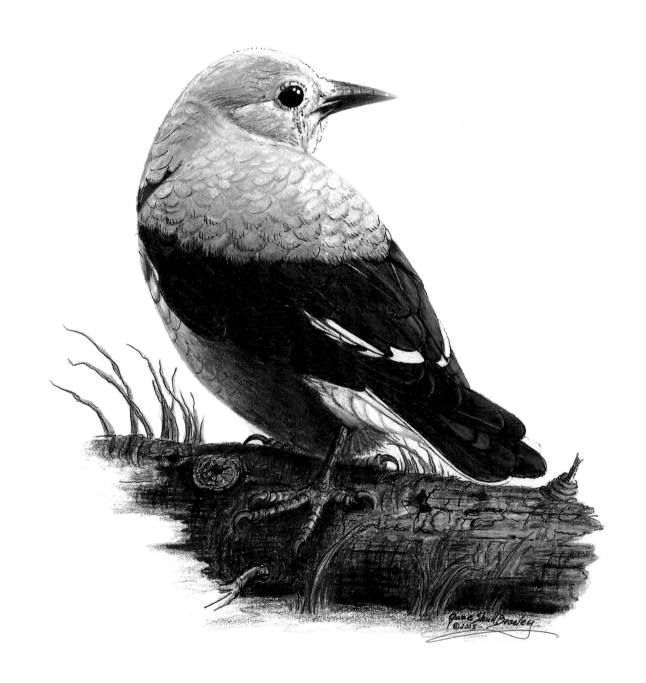

58

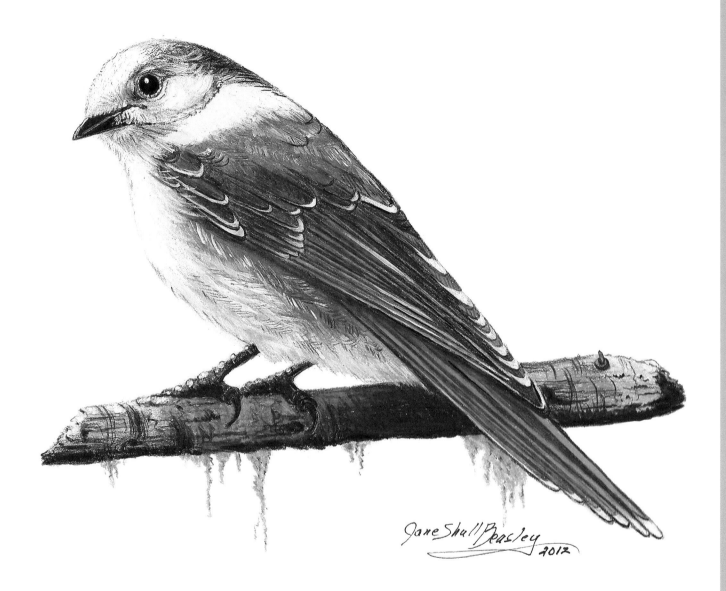

Gray
Jay

Sexes alike

Size: 12"

Food: seeds, insects and fruit

Birdfeeder bird: sometimes

Nest: cup

Eggs: 3-4, gray white

Jane says:

"also known as the camp robber"

Black-capped Chickadee

Sexes alike

Size: 5"

Food: seeds, suet and insects

Birdfeeder bird: yes

Nest: cavity/birdhouse

Eggs: 5-7, white with fine brown markings

Jane says:

"probably the most recognized bird besides the hummingbird"

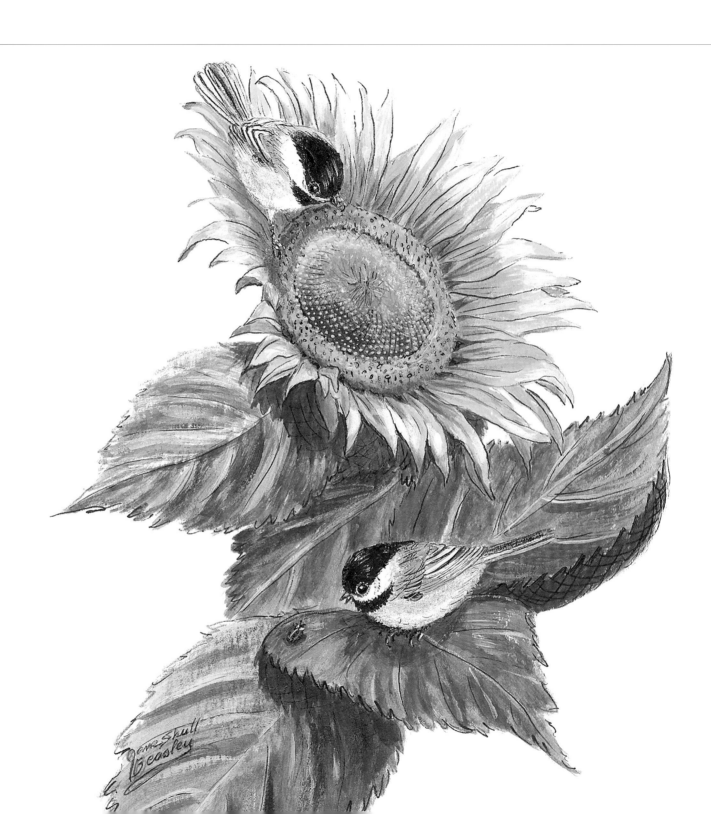

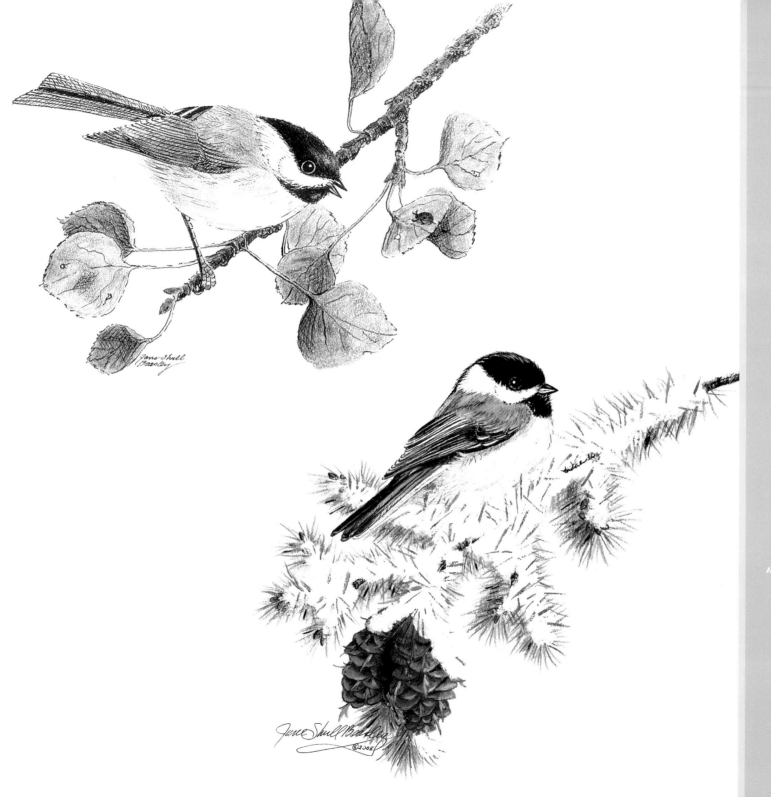

Jane says:

*"year-round
resident;
doesn't migrate"*

61

Common Loon

Sexes alike

Size: 32"

Food: fish and aquatic insects

Birdfeeder bird: no

Nest: on ground

Eggs: 2, olive-brown

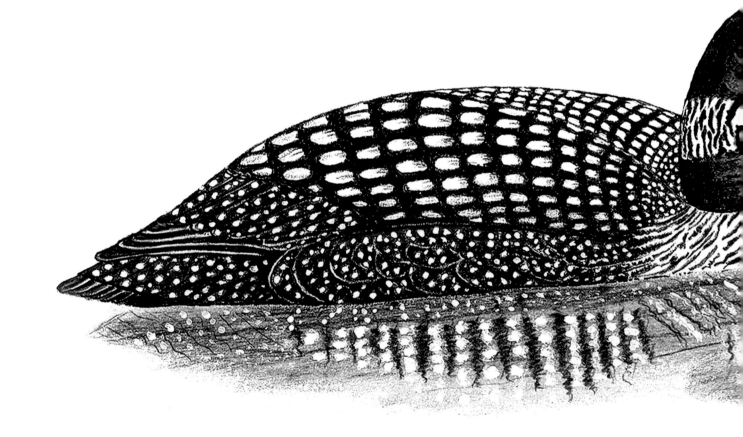

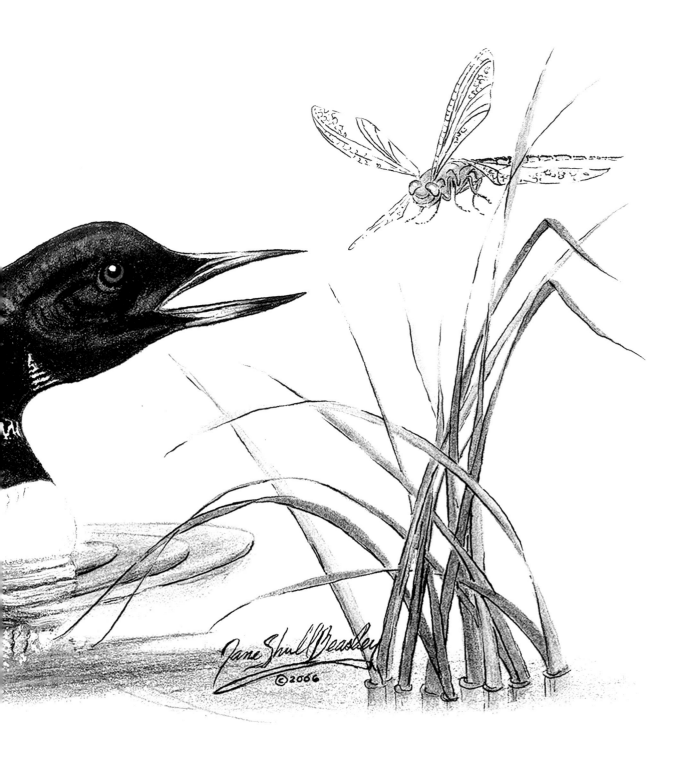

Jane says:

"new hatched chicks will ride on the back of the adult bird"

Mourning Dove

Sexes alike

Size: 12"

Food: seeds

Birdfeeder bird: yes

Nest: platform

Eggs: 2, white without markings

Jane says:

"familiar bird sound from old westerns"

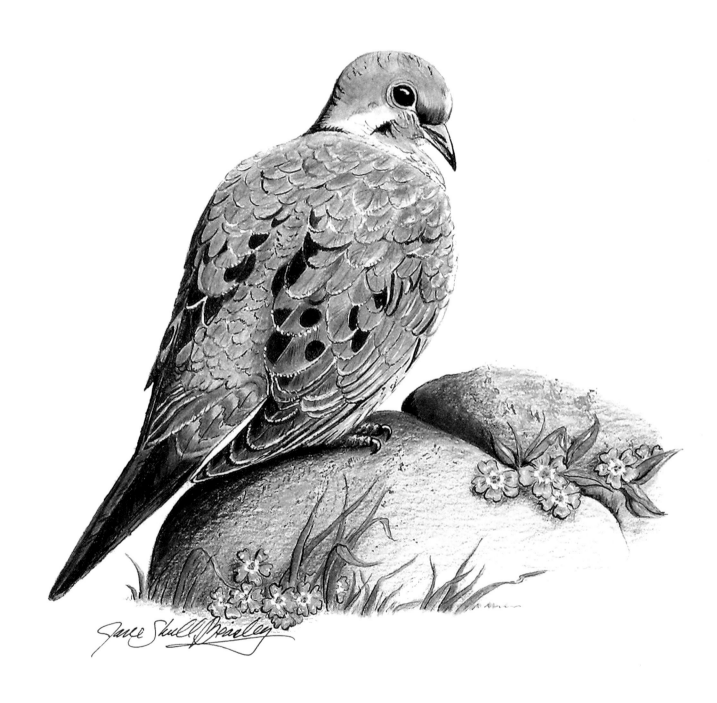

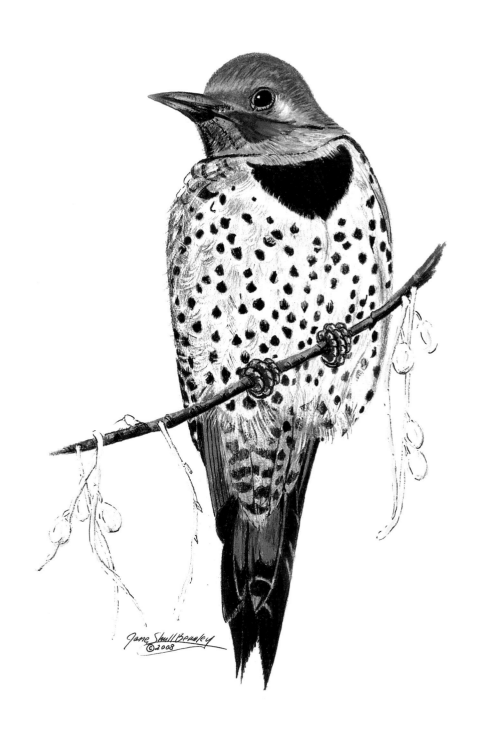

Northern Flicker

Male

Size: 12"

Food: seed, suet and insects

Birdfeeder bird: yes

Nest: cavity/birdhouse

Eggs: 5-8, white without markings

Jane says:

"will often pound on a metal chimney vent to attract a mate and establish a larger territory"

Common Loon

Sexes alike

Size: 32"

Food: fish and aquatic insects

Birdfeeder bird: no

Nest: on ground

Eggs: 2, olive-brown

Jane says:

"dive completely underwater for up to 15 minutes while fishing"

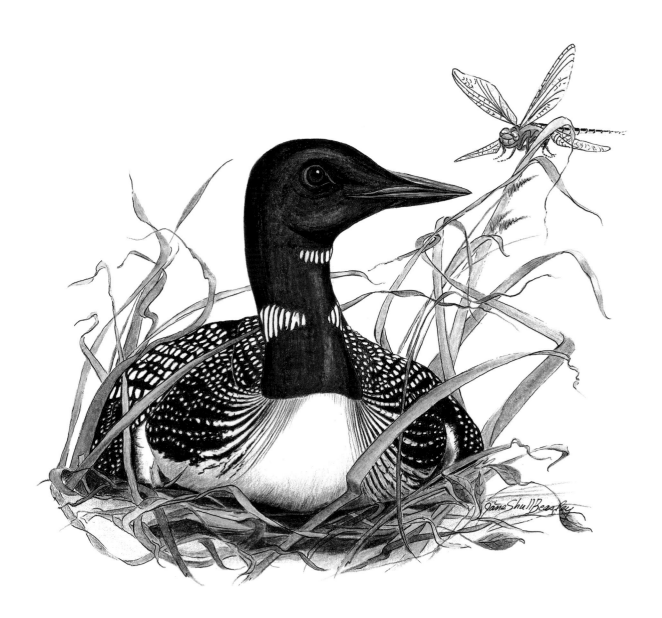

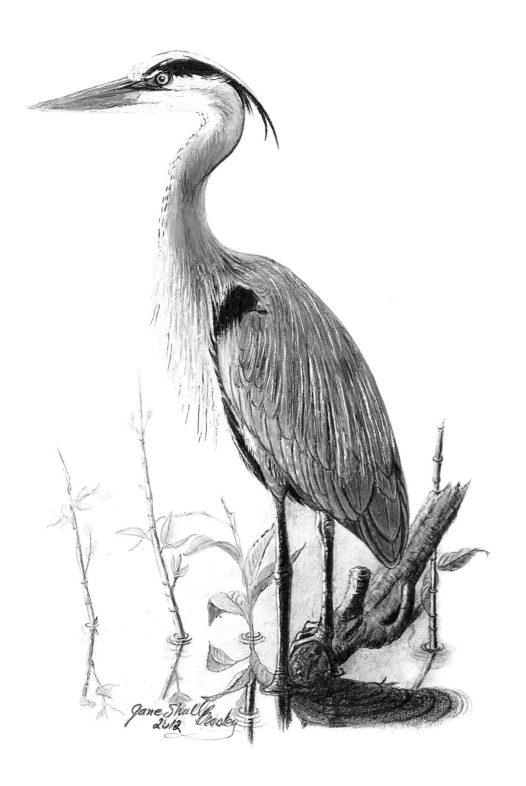

Great
Blue Heron

Sexes alike

Size: 42–52"

Food: small fish, frogs, snakes and insects

Birdfeeder bird: no

Nest: platform

Eggs: 3–5, blue-green without markings

Jane says:

"swallows a

fish head first"

Black-capped Chickadee

Sexes alike

Size: 5"

Food: seeds, suet and insects

Birdfeeder bird: yes

Nest: cavity/birdhouse

Eggs: 5-7, white with fine brown markings

Jane says:

"they will hold a seed with their feet and break it open"

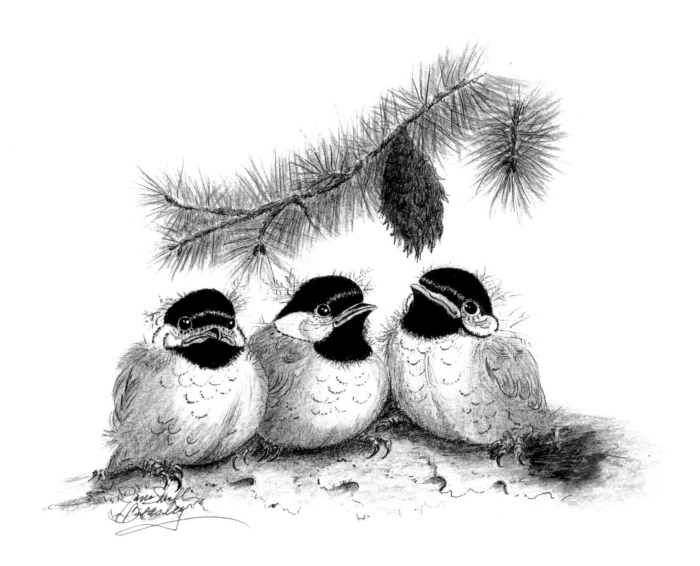

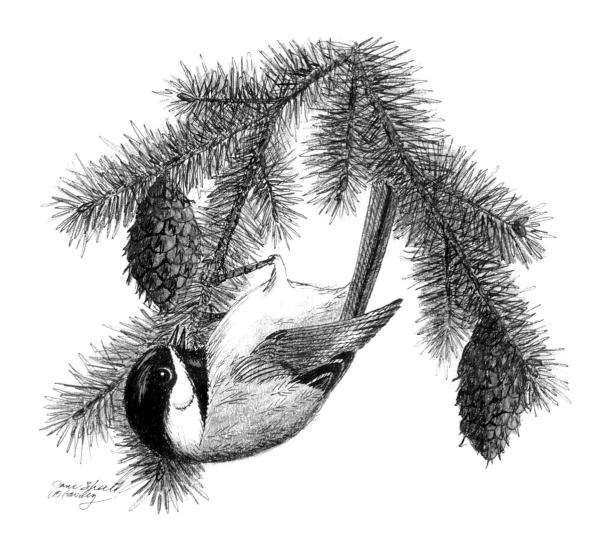

Jane says:

"they are the busybodies of the forest"

Canada Goose

Sexes alike

Size: 25-43"

Food: aquatic plants, insects and seeds

Birdfeeder bird: no

Nest: platform

Eggs: 5-10, white without markings

Jane says:

"this regal bird has become a nuisance in urban settings"

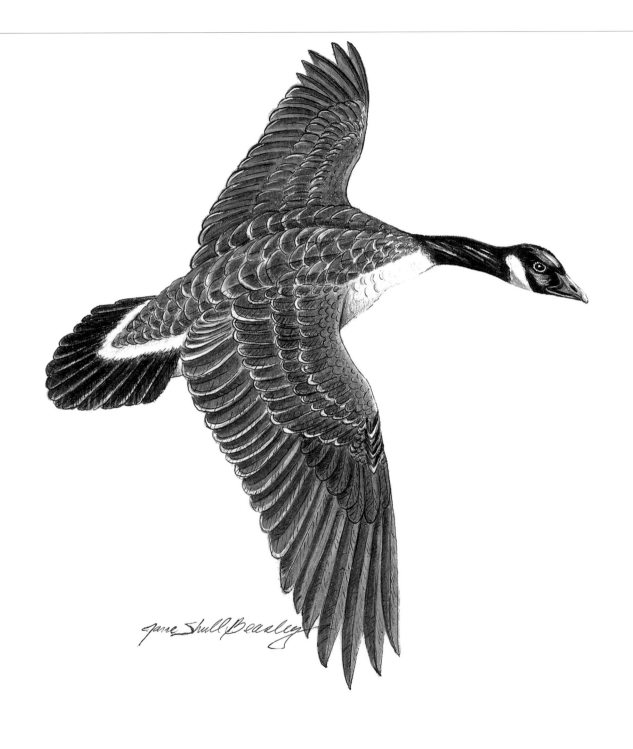

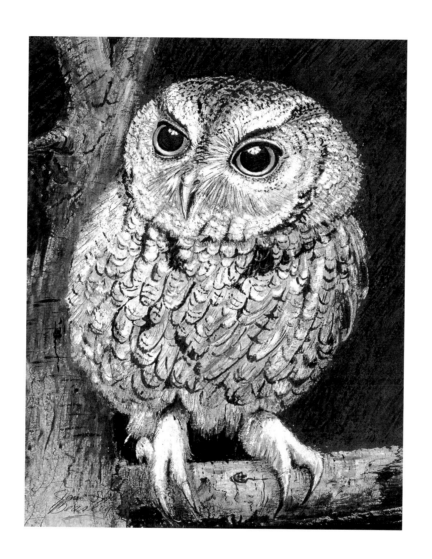

Western Screech Owl
Sexes alike

Size: 8.5"

Food: insects and small mammals

Birdfeeder bird: no

Nest: cavity

Eggs: 2-6, white without markings

Jane says:

"will nest in cavities created by other birds"

Where to find Jane's birds

● Year-round　　○ Winter　　● Summer

Red-winged
Blackbird
p. 26

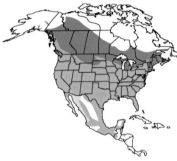

Yellow-headed
Blackbird
p. 27

Mountain
Bluebird
p. 8

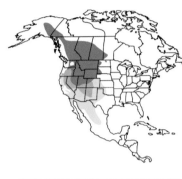

Lark
Bunting
p. 22

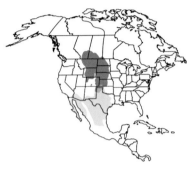

Lazuli
Bunting
p. 31

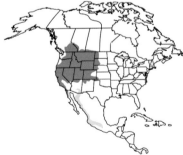

Northern
Cardinal
p. 23

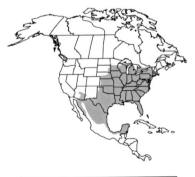

Black-capped
Chickadee
pp. 5, 6, 7, 24, 47
60, 61, 68, 69
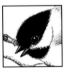

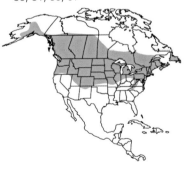

Mountain
Chickadee
p. 46

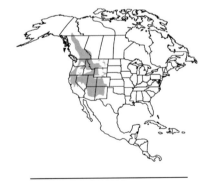

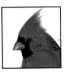

Mourning Dove

p. 64

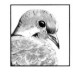

Bald Eagle

pp. 44, 45

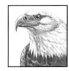

Golden Eagle

p. 28

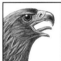

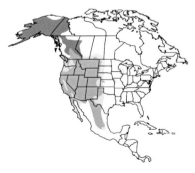

House Finch

pp. 30, 55

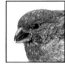

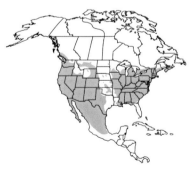

Where to find Jane's birds

Northern Flicker

p. 65

American Goldfinch

pp. 20, 21

Canada Goose

p. 70

Evening Grosbeak

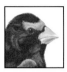

p. 34

Mourning Cloak, Montana state butterfly

Great Blue Heron

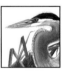

pp. 14, 67

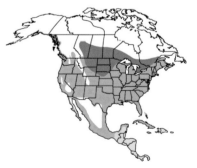

tansyleaf aster

Jane Shull Beasley

74

Ruby-throated
Hummingbird

p. 19

Rufous
Hummingbird

pp. 18, 42

Blue
Jay

p. 49

Gray
Jay

p. 59

Steller's
Jay

p. 35

blackeyed susan

Where to find Jane's birds

Dark-eyed Junco
p. 13

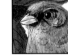
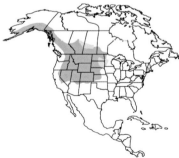

American Kestrel
p. 29

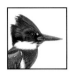
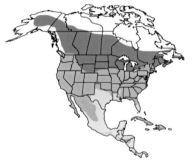

Belted Kingfisher
p. 56

Common Loon
pp. 62, 66

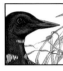

Black-billed Magpie
p. 48

Western Meadowlark
p. 9

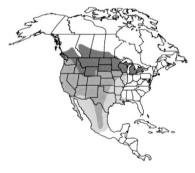

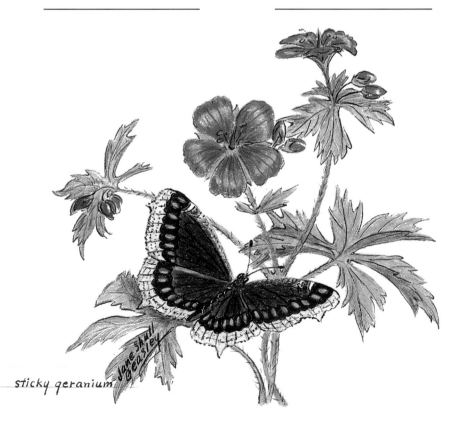

sticky geranium

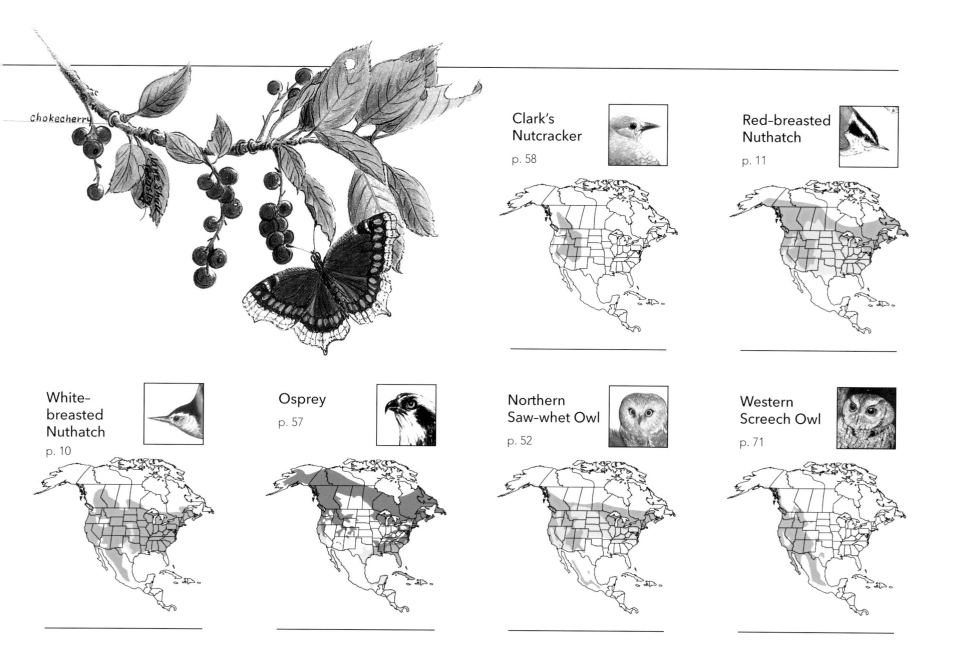

chokecherry

Clark's Nutcracker
p. 58

Red-breasted Nuthatch
p. 11

White-breasted Nuthatch
p. 10

Osprey
p. 57

Northern Saw-whet Owl
p. 52

Western Screech Owl
p. 71

Where to find Jane's birds

Ring-necked
Pheasant

p. 33

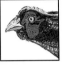

Pine
Siskin

p. 54

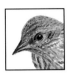

White-tailed
Ptarmigan

p. 32

Horned
Puffin

p. 41

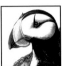

Common
Raven

p. 50

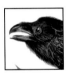

Greater
Roadrunner

p. 40

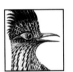

American
Robin

p. 12

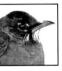

Western
Tanager

pp. 16, 17

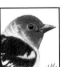

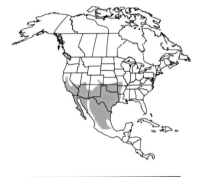

pussy

Yellow-rumped Warbler
p. 37

Bohemian Waxwing
p. 38

Bitterroot, Montana state flower

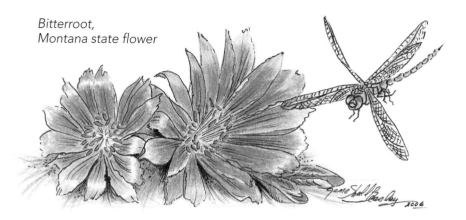

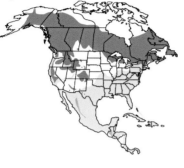

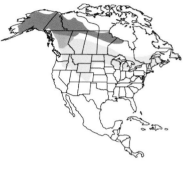

Cedar Waxwing
pp. 38, 39

Downy Woodpecker
p. 53

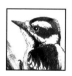

Cactus Wren
p. 36

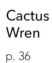
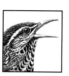

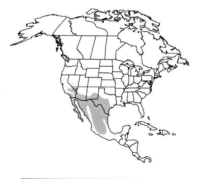

ACKNOWLEDGMENTS

To those who created all the field guides and books before her.

To family who always encouraged her to pursue her artistic gift.

To Birds & Beasleys family who shared her dream and love of birds.

To her fans and collectors of her art.

To Bruce Capdeville who designed this book.

To Anna Senecal who created the bird maps.

To Jennifer Schneider who digitalized and formatted all the original drawings.

To Bob Martinka whose photographs and knowledge were invaluable.

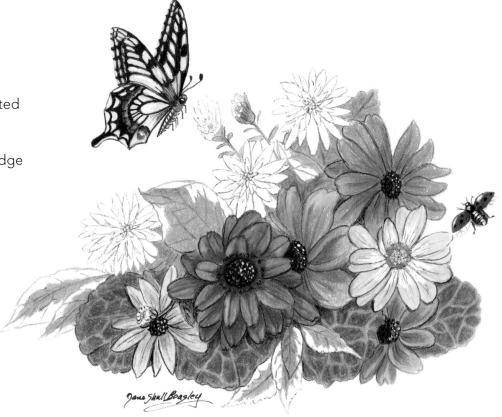